TROPE

KEIR GRAFF

CHICAGO'S FINE ARTS BUILDING

MUSIC, MAGIC, AND MURDER

PRINCIPAL PHOTOGRAPHY
BY TOM MADAY

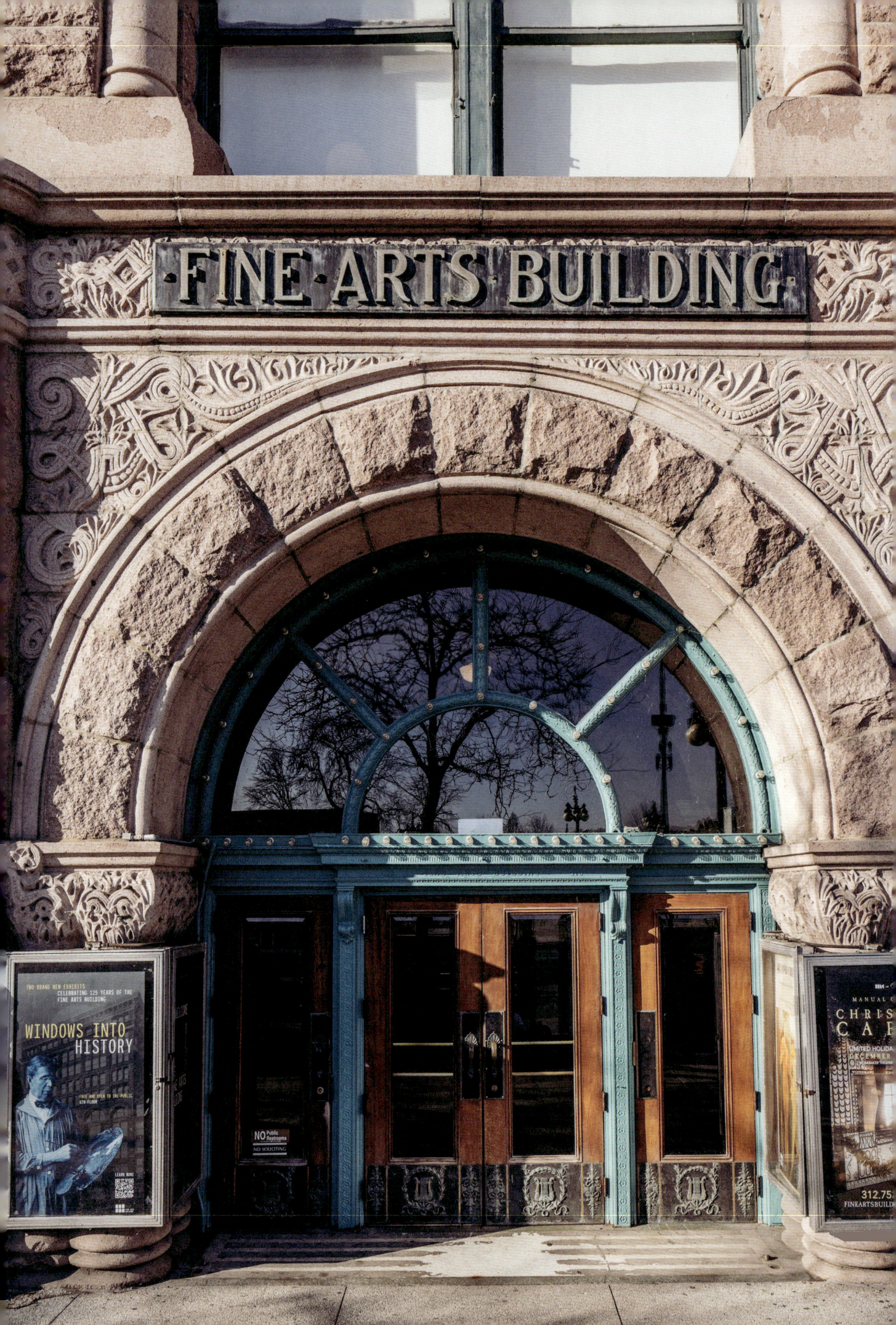

FOR MARYA,
MY FAVORITE ARCHITECT

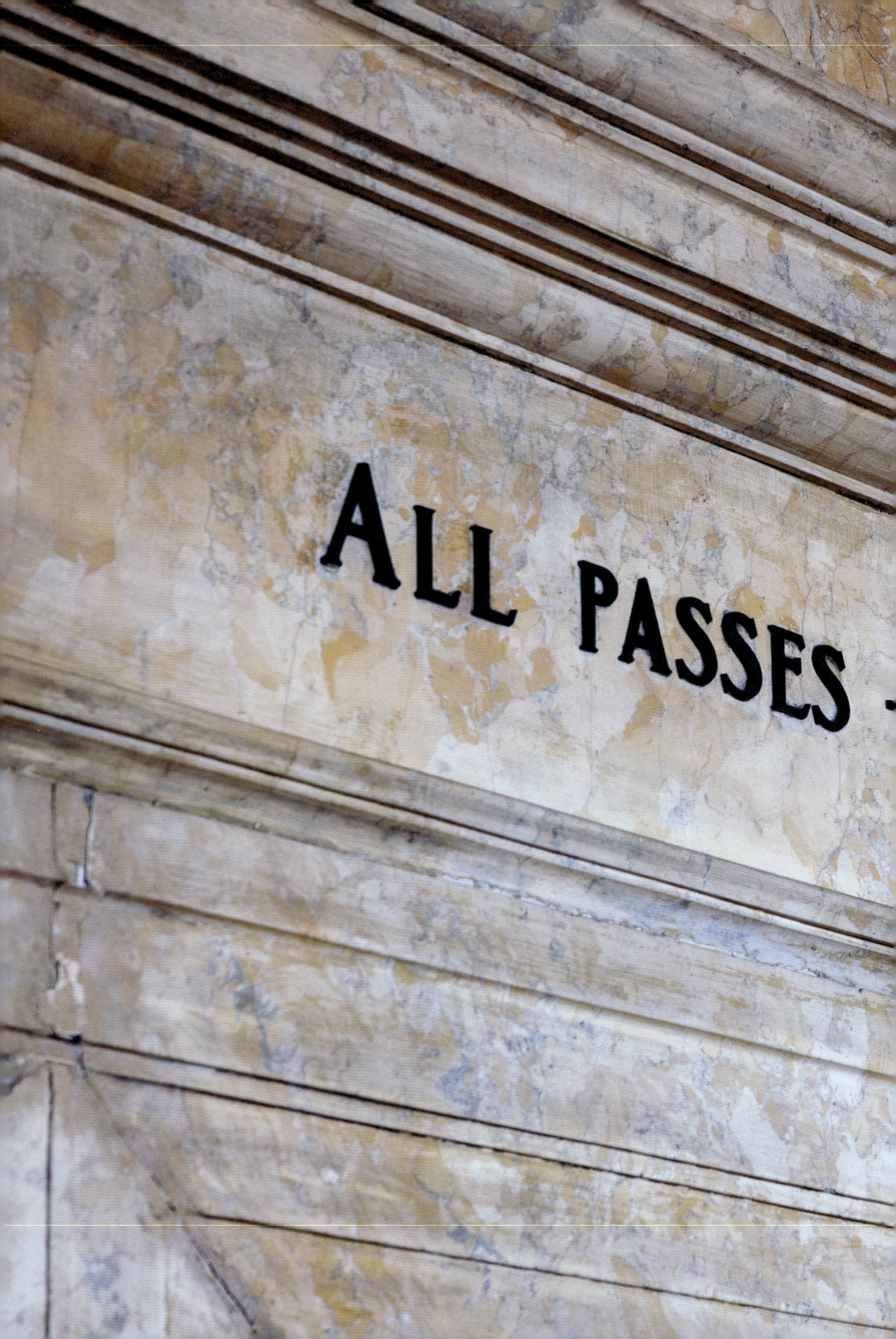

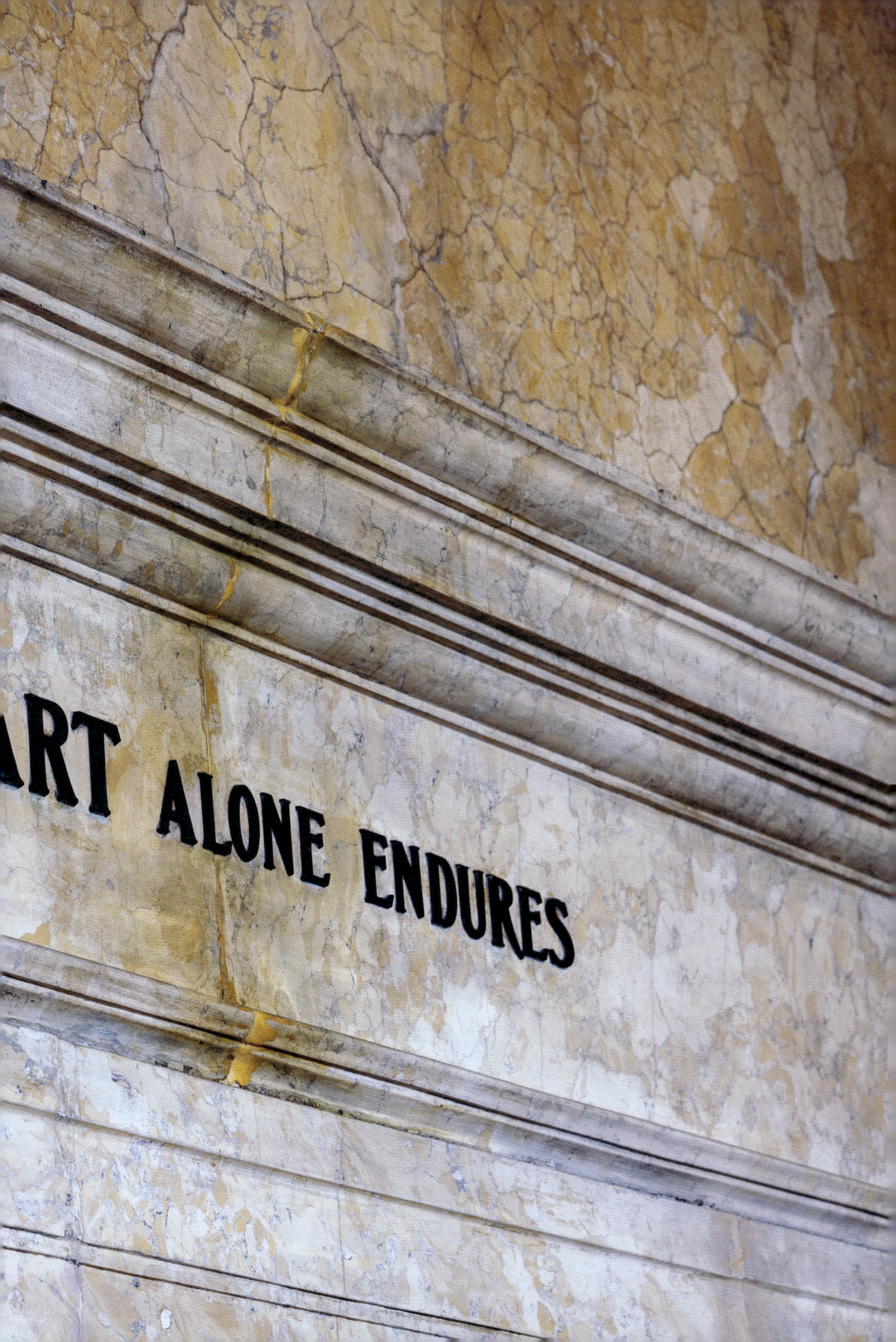

TABLE of CONTENTS

9	Preface by Brian Hieggelke
10	Foreword by Gillian Flynn
14	Overture
19	Act One: A Building Reborn
41	Interlude: Chicago's Citizen Kane
49	Act Two: Art Colony in Decline
61	Interlude: The Theaters
85	Act Three: Shabby Grandeur
93	Interlude: Death in the Afternoon
101	Act Four: Renaissance
109	Interlude: A Thrilling Ride
121	Act Five: The Artists Endure
177	Acknowledgments
179	About the Author
181	Photo Credits

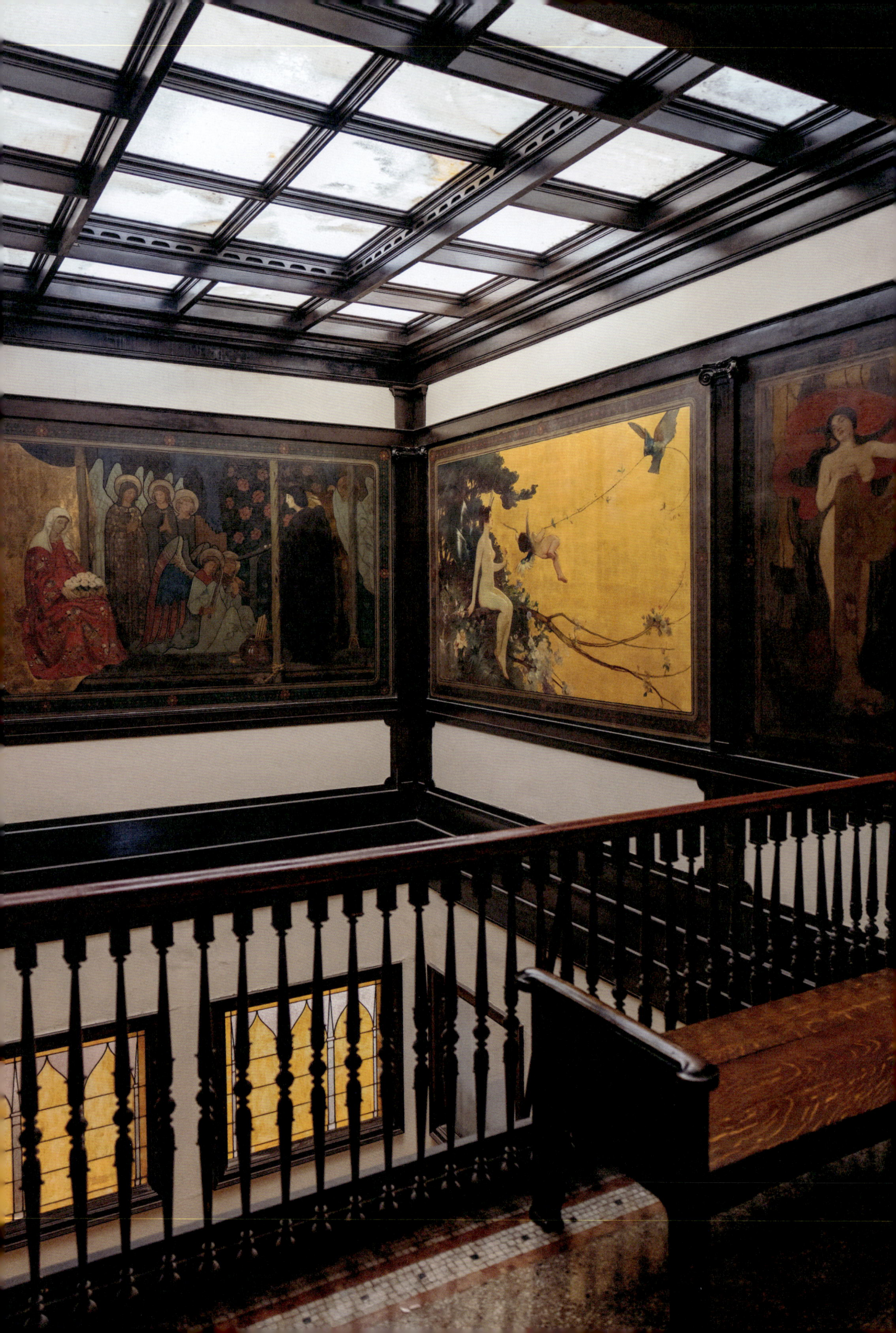

PREFACE

BRIAN HIEGGELKE
Editor and Publisher, *Newcity*

WHEN *NEWCITY* PUBLISHED OUR STORY ABOUT THE PAST AND PRESENT OF THE FINE ARTS BUILDING IT WAS, BY FAR, THE LONGEST WE'D EVER PUBLISHED.

The undertaking came about, as all great stories do, over cocktails. I'd run into Keir Graff at former *Newcity* managing editor Frank Sennett's book-release party for his latest thriller. Keir, like Frank, landed in Chicago the old-fashioned way, that is, via Missoula, Montana. (Though not on horseback.) And, like Frank, he earned his *Newcity* bona fides in the nineties writing about drinking.

Catching up over drinks at Frank's party, I learned that Keir, who'd left his job as executive editor of *Booklist* to write full-time, had taken an office in the Fine Arts Building, which is a modest walk from *Newcity* HQ. I suggested we meet up and have a cocktail sometime, and a month or two later, there we were, drinking Perfect Manhattans at the bar in the lobby of the Palmer House.

As you might guess, Keir and I share an appreciation for fine vintage things, like majestic hotels, classic cocktails, and historic buildings like the Fine Arts. Eager to bring Keir back into the fold of *Newcity* contributors, I suggested an in-depth story about the Fine Arts, and cited Joseph Mitchell's McSorley's stories from the *New Yorker*, circa 1940, as inspiration. At least I think that's how it went down. Cocktails, you know.

And so, a couple of seasons and nearly twenty-five thousand words later, we published our story. Keir took the idea that day and delivered a story far more detailed, and far more interesting, than I could have hoped for.

After the story came out, the response was pretty amazing. Who says people won't read long stories? They will read long stories that are worth reading, like this one. We still get orders for this issue.

So, naturally, a book made sense. This one-of-a-kind writing about a one-of-a-kind place needs to be preserved for posterity, and shared long after the shelf life of a magazine. After much discussion, Keir decided that the book should be a big art book, where the writing and visual characterization of the subject would match up. I introduced Keir to Sam Landers, the founder of Trope Publishing, who has been producing truly gorgeous books about Chicago and other places, and here we are. To paraphrase a building, Fine Arts alone endures.

FOREWORD

GILLIAN FLYNN
#1 *New York Times* best-selling author

WALK INTO THE FINE ARTS BUILDING AND YOU WILL IMMEDIATELY SEE, LETTERED OVER THE DOORWAY: "ALL PASSES—ART ALONE ENDURES." It's a phrase of encouragement, delight, wonder; and a sly prod to get to work. It urges you to avoid watching those kitten videos on YouTube today. It gives you the courage, and the pride, to create. It's the reason I walked in and immediately thought: I *must* work here. This is my *place*.

The Fine Arts Building has a fine view of Lake Michigan to the east, and an equally fine view from virtually anywhere within. It is designed to invoke wonder. Everywhere you turn, there is art. Venture to the top floor and breathe in life both current and antique, then take the stairs down and down. Run your hands over worn railings and imagine the hundreds of other hands, over decades and decades, that have trailed them. Let the building haunt you; it's a place where you can feel the energy of the past. You can envision eager flappers from the 1920s, perfecting the Charleston in hopes of dazzling on the stage. You can imagine musicians, zazzing on their trumpets, eager to entertain Sinatra's toddlin' town. You can almost hear novelists tapping away at their Underwoods with visions of setting literary America ablaze. Grab these artists' energy: you'll feel the power of thousands of dreams and plans and toilings (because despite what some think, creation requires not just a benevolent muse but also pure grit).

Look around: everywhere there are details to delight the eye. Ride the elevators that clank up and down, fronted with glass so you can see each level pass by. But also look at the intricate curlicue ironwork that frames the elevators and the still-working, still-beautiful clocks above them that remind you time is moving by: go, go, *go*! Examine the sconces on the walls, the curve of the steps; even the doors to each office. This building was made at a time when people sincerely valued beauty.

But despite its inherent grace, the Fine Arts Building is most alive with the murmur (and sometimes bellow) of art. Walk about and you'll hear trombones down one hallway; an opera company down another. A singer trills her scales from a corner office; keen readers discuss novels in the second-floor

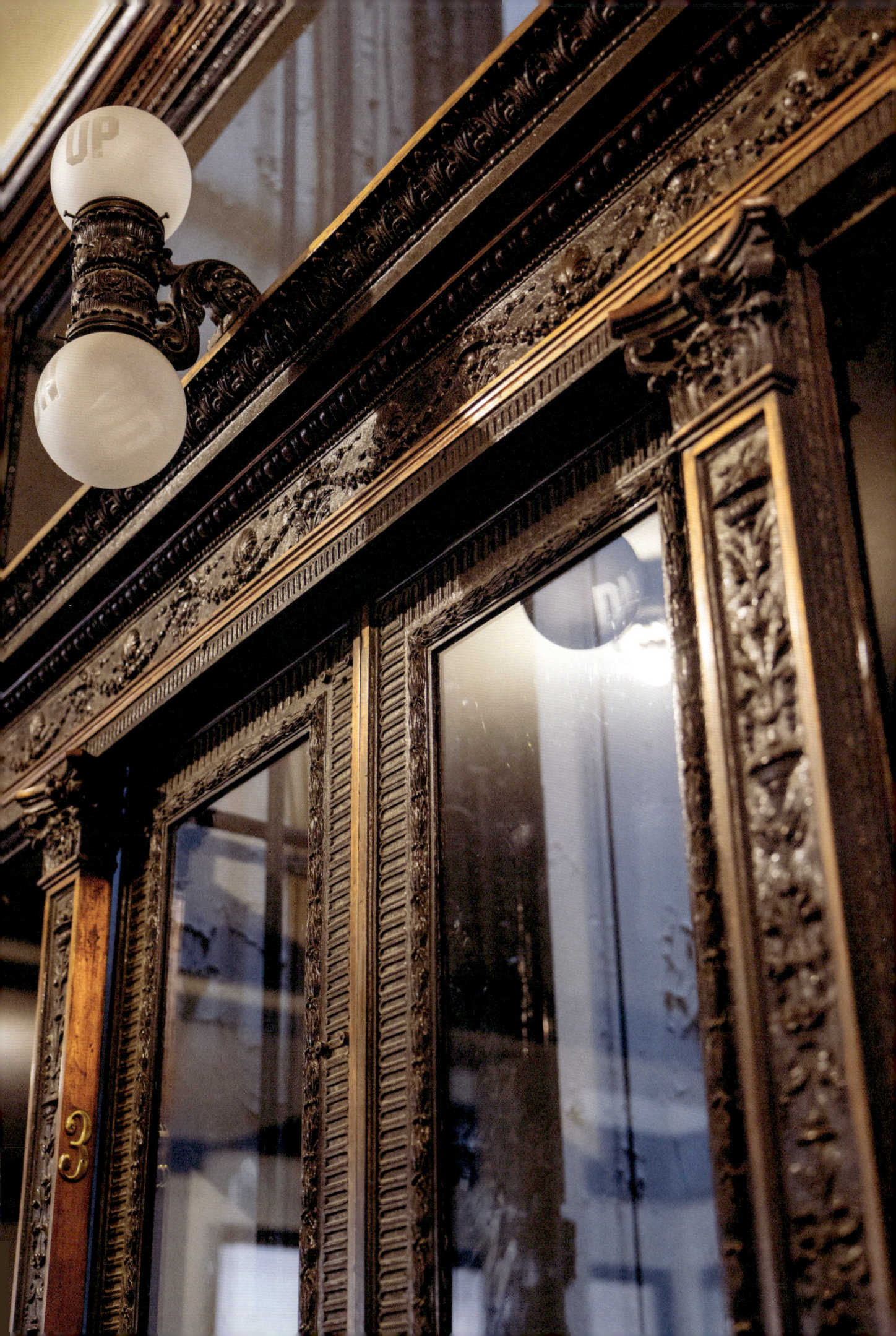

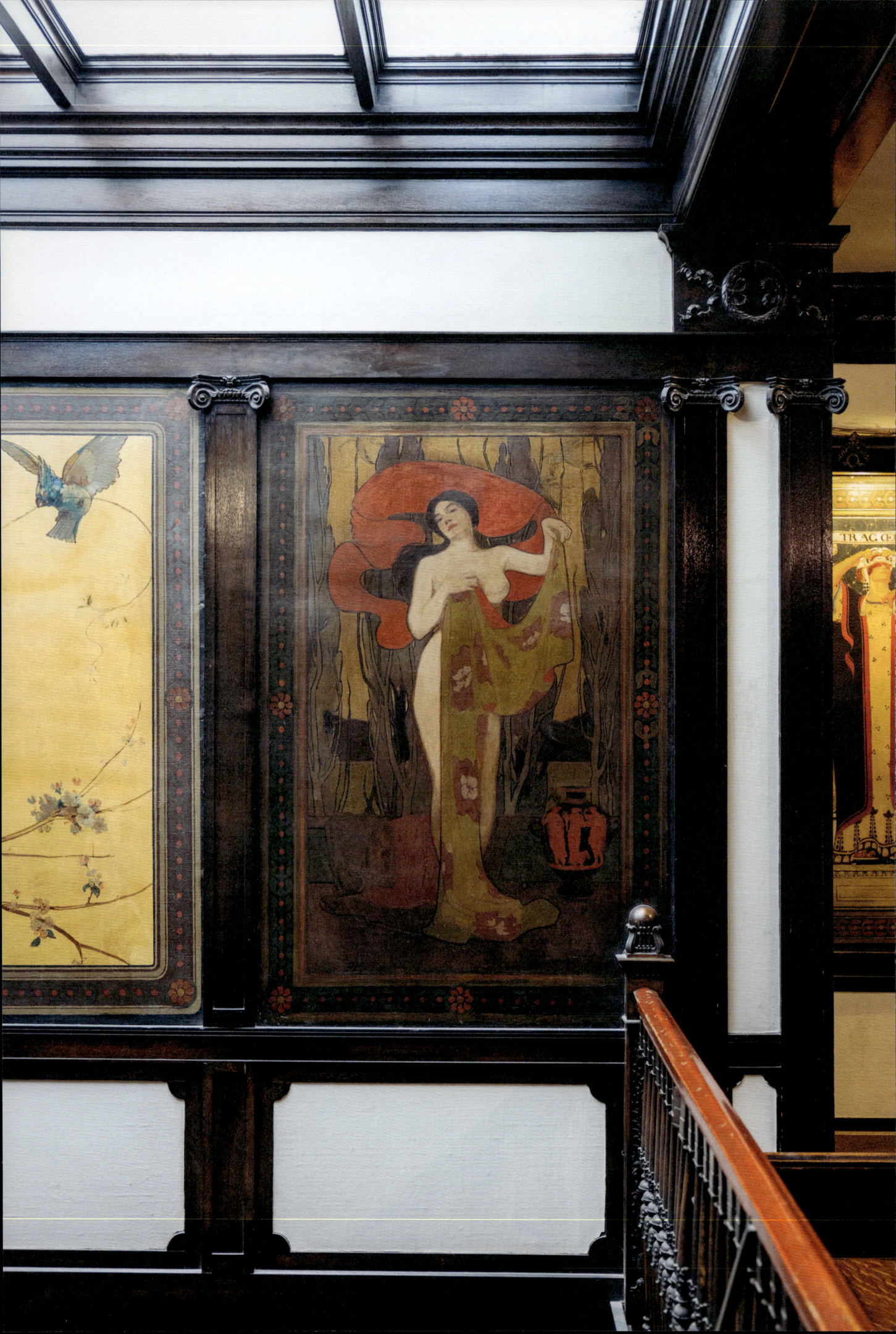

bookstore; actors rush to enliven the ground-floor Studebaker stage. The bursts of beautiful noise create no cacophony, I swear. They are a reassuring sound, even to a writer tussling with her next novel: they remind me that I am lucky to create for a living. The ambient noise both lightens and anchors the Fine Arts Building. You know that here, ideas and beauty take flight; and you are reminded that creation demands practice and sacrifice and courage and a strong, sturdy spine.

You are also urged to join us: everywhere are invitations to partake. Learn to sing! Buy a violin! Take a photo! The sign that entices me the most is for Adult Tap Dancing. I'll let you know if I ever dare—highly improbable, yet in this building the idea of a gangly writer performing a cramp roll seems nearly viable.

In short: you can't leave the Fine Arts Building without being lifted, thrilled, hopeful, and welcome, whether you make art or receive it. If you are the latter, thank you, because all good artists know we are at the mercy of those kind enough to be our audience. This is your place, too.

Come visit.

OVERTURE

EVERY BUILDING HIDES A WORLD BEHIND ITS DOORS—EVEN BLANK-FACED OFFICE BLOCKS HAVE A HISTORY AND A SOCIAL LIFE—BUT NO CHICAGO BUILDING HIDES MORE WORLDS THAN THE FINE ARTS BUILDING.

It's not always obvious how much is happening inside the ten-story building at 410 South Michigan Avenue, despite the ornate display cases whose posters advertise events at the Studebaker Theater. In recent years, the soaring shop windows facing the sidewalk have been alternately papered over, and boarded up, as management searched for new retail tenants and rebuilt its restaurant space.

For six decades, the building had a front room: George Mitchell's Artist's Cafe, its singular apostrophe a landmark in neon and runner lights. It closed in 2019, as though its owners sensed the coming pandemic. Almost everyone agreed the food was average, the service indifferent, the prices exorbitant. But almost everyone misses it. On Yelp, where the most common rating was one star, one reviewer summed it up by writing, "It's odd to avoid a place but then hope it doesn't go away."

The green-painted iron framing the front doors shows some rust, the lyres on the ornamented kick plates are tarnished, and the varnish on the inner doors is chipped from heavy use. But go under the inscription "All passes—art alone endures" and push through the door into Durkin Hall. You'll feel as though you've just stepped out of a time machine.

The lobby of the Fine Arts Building has a high, gracefully vaulted ceiling. The walls and ceiling are elegantly covered in light ochre scagliola, plaster treated to resemble marble. A scrollwork clock keeps accurate time. A long crack runs north to south in the terrazzo floor, as though tectonic plates have shifted since the building's construction.

Whether you climb the scalloped marble stairs or ride up in the human-operated elevators—more on those later—you'll be exploring a warren of hallways that doesn't look all that different from 1898, the year the building was dedicated.

Yes, there are inevitable reminders of the twenty-first century in white plastic security cameras, in the metal conduit snaking over door mantles, in the cables clogging the glass-fronted mail chute, and computer screens that glow behind pebble-glass windows in a few studio doors. But the halls reverberate with timeless music. Sopranos soar up to the high notes as violin bows draw tunes from taut strings. Someone plays a piano so busily

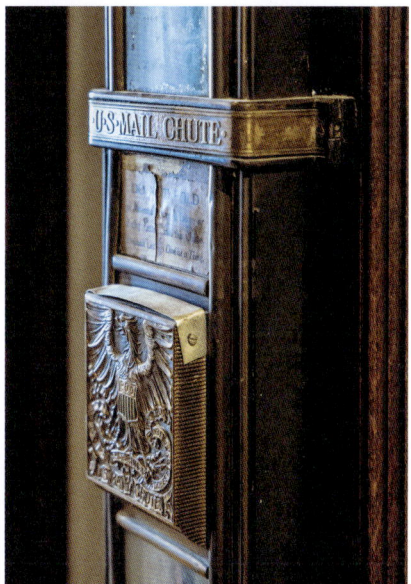

they must have twelve fingers. Dancers' feet thud against wooden floors. Somewhere, a tuba burps out "Ride of the Valkyries." And more quietly, behind closed doors, painters paint, writers write, and luthiers shave soft ribbons from billets of spruce.

Other Chicago landmarks have more stunning architecture or are more perfectly restored, but no building in Chicago has aged so well—because in the Fine Arts Building, it's the work that has been preserved. Two centuries have turned since its dedication and yet it remains defiantly unmodernized. However improbably, its purpose remains the same: to provide artists and artisans not only a space to pursue their callings, but community with others, a living demonstration that something good happens when so many creatives work so closely to each other.

Which is not to say it's always been easy. What ever comes easily in the arts?

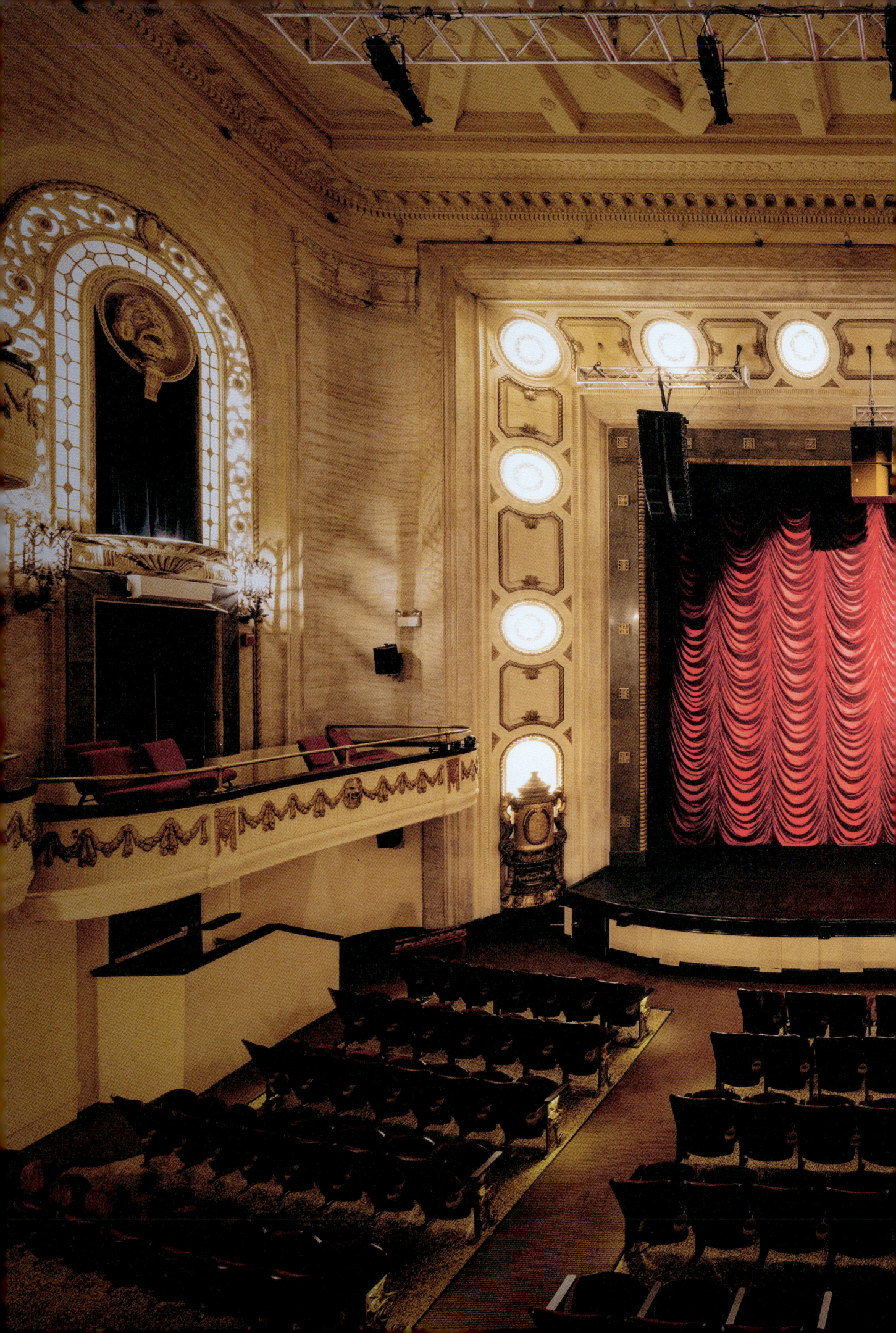

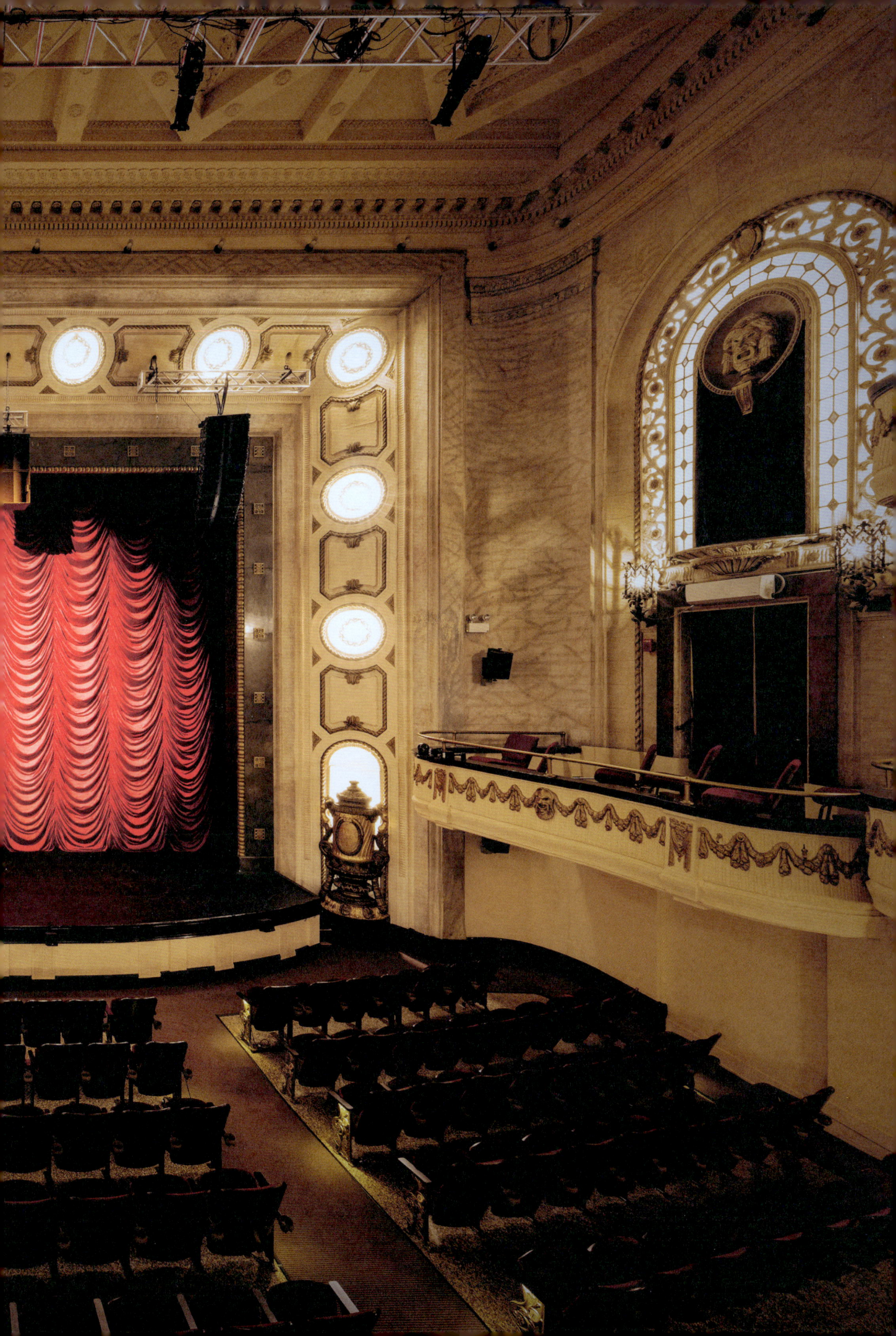

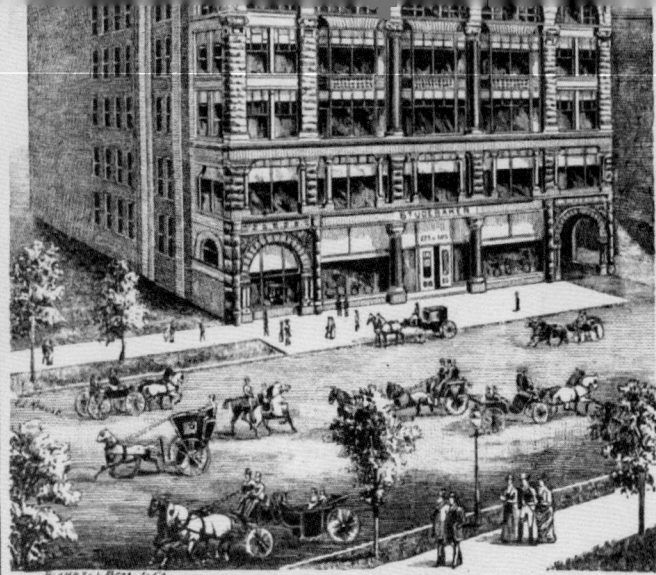

STUDEBAKER CARRIAGE FACTORY AND REPOSITORY, CHICAGO, ILL.

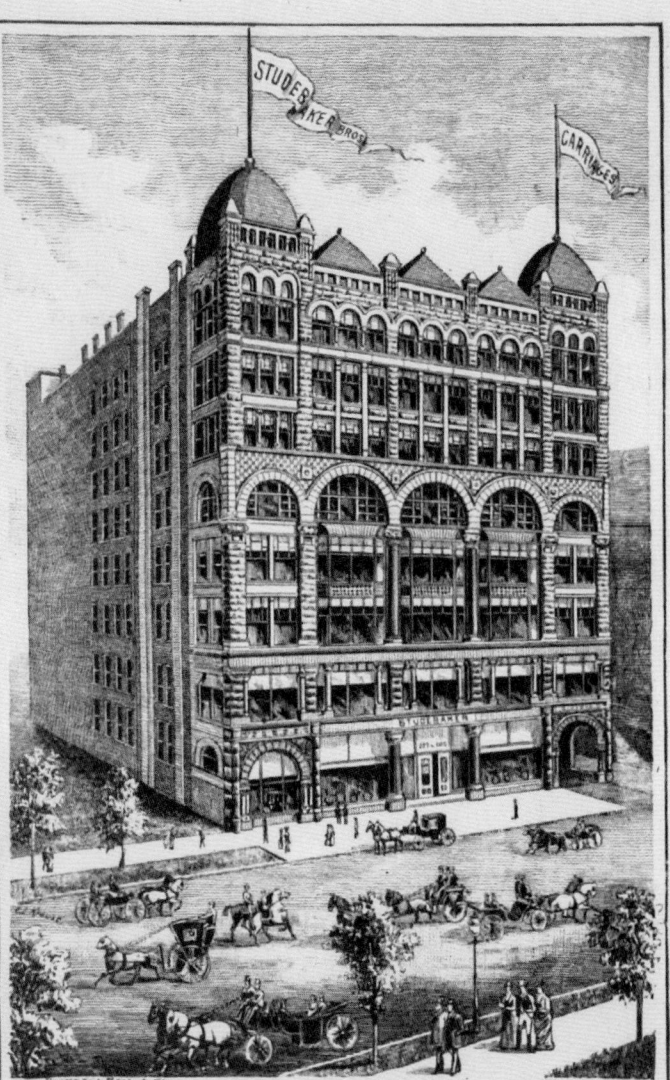

STUDEBAKER CARRIAGE FACTORY AND REPOSITORY, CHICAGO, ILL.

Studebaker Bros. Manufacturing Co.,

Rules for the Care and Preservation of Carriages.

1. Carriages should be kept in an airy, dry coach house. There should be a moderate amount of otherwise the colors will be affected. The windows should be curtained, to avoid having direct sunlight upon a carriage.

2. There should be no communication between the stable and the coach house. The manure he pit should also be located as far away from the carriage house as possible. Ammonia fumes crac destroy varnish, and fade the colors both of painting and lining. Also avoid having a carriage stand n brick wall, as the dampness from the wall will fade the colors and destroy the varnish.

3. When a carriage is new or newly varnished, it is better for it to stand a few days and to be frequ washed and well dried off before being used; frequent washings with cold water and exposure to fresh air shade will also help to harden and brighten its finish. *Never allow mud to remain long enough upon a varnished carriage to dry upon it, or spots and stains will invariably result*

4. While washing a carriage, keep it out of the sun. *Use plenty of water*, taking great care that it driven into the body, to the injury of the lining. Use for the body panels a large, soft sponge; when satu squeeze this over the panels, and, by the flowing down of the water, the dirt will soften and ha mlessly r Care should be taken to wipe the surface quite dry with soft chamois leather after each washing.

5. The directions just given for washing the body apply as well to the under-parts and wheels, b for the latter a different sponge and chamois than those used on the body. Never use a "spoke brush," in conjunction with the grit from the road, would act like sand-paper on the varnish, scratching it, a course, removing the gloss.

6. Never allow water to dry of itself on a carriage, as it would invariably leave stains. Hot wa soap should never be used in washing a varnished surface.

7. Enameled leather tops should be washed with very weak soap and water.

8. To prevent or destroy moths in woolen linings, use turpentine and camphor. In the case of a carriage, the simple evaporation from this mixture, when placed in a saucer (the glasses being closed,) v found a certain cure.

9. Inspect the entire carriage occasionally, and when even a bolt or clip appears to be getting tighten it up with a wrench, and always have little repairs done *at once*. Should the tires of the wheels all slack, so that the joints of the felloes become visible, have them immediately contracted, or the whee be permanently injured. "A stitch in time saves nine!"

10. Examine the axles frequently; keep them well oiled, and see that the washers are in good Pure sperm oil is considered the best for lubricating purposes; castor oil will answer; but *never use sw* as it will gum up. Be careful, in replacing the axle-nuts, not to cross the thread, or strain them.

11. Leather top carriages should never stand long in the carriage house with the top down. raising the top, "break" the joints slightly, to take off the strain on the webstay and leather. Aprons of kind should be frequently unfolded, or they will soon spoil.

CHICAGO REPOSITORY and FACTORY:

203-4-5-6 MICHIGAN AVENUE,

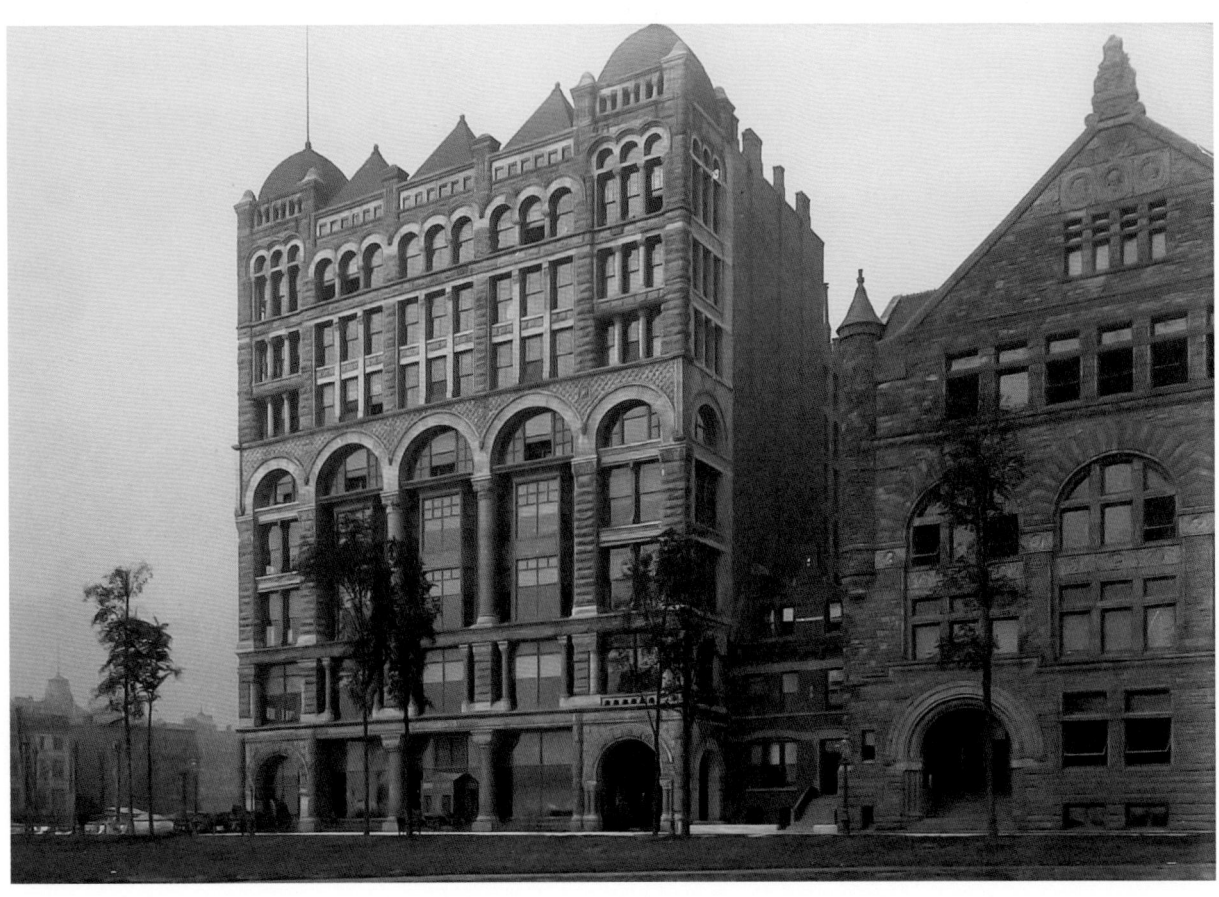

ACT ONE

THE FINE ARTS BUILDING, DEDICATED IN 1898, FIRST OPENED ITS DOORS IN 1885 AS THE STUDEBAKER BROTHERS' EIGHT-STORY LAKE FRONT CARRIAGE REPOSITORY. Designed by Solon S. Beman, the architect who drew up George Pullman's company town on Chicago's South Side, its lower four floors had showrooms with high ceilings and large windows, housing as many as two thousand wagons and buggies at a time. Assembly and repair took place on the upper four floors.

Upon the building's opening, the *Chicago Tribune*, no stranger to hyperbole, judged it a "Magnificent Palace . . . a lasting ornament as beautiful and as artistic as the Arc de Triomphe or the Column Vendôme." Seeking more quantifiable brags, boosters also touted the prosaic but unverified claim that it boasted the largest polished granite columns in the United States.

But the Studebaker Brothers Manufacturing Company quickly outgrew its showplace. In 1896, it moved into a new ten-story structure, also designed by Beman, at what is now numbered 623 South Wabash. (It still stands and is a mixed-use building owned by Columbia College.) The original Michigan Avenue building would have been sold to another company if Charles C. Curtiss hadn't come up with a better idea.

A Civil War veteran and the son of two-time Chicago mayor James Curtiss, Charles Curtiss had practical experience in both business and the arts. He

ABOVE Original building as the Studebaker Brothers' Carriage Repository, 1885

ACT ONE: A BUILDING REBORN

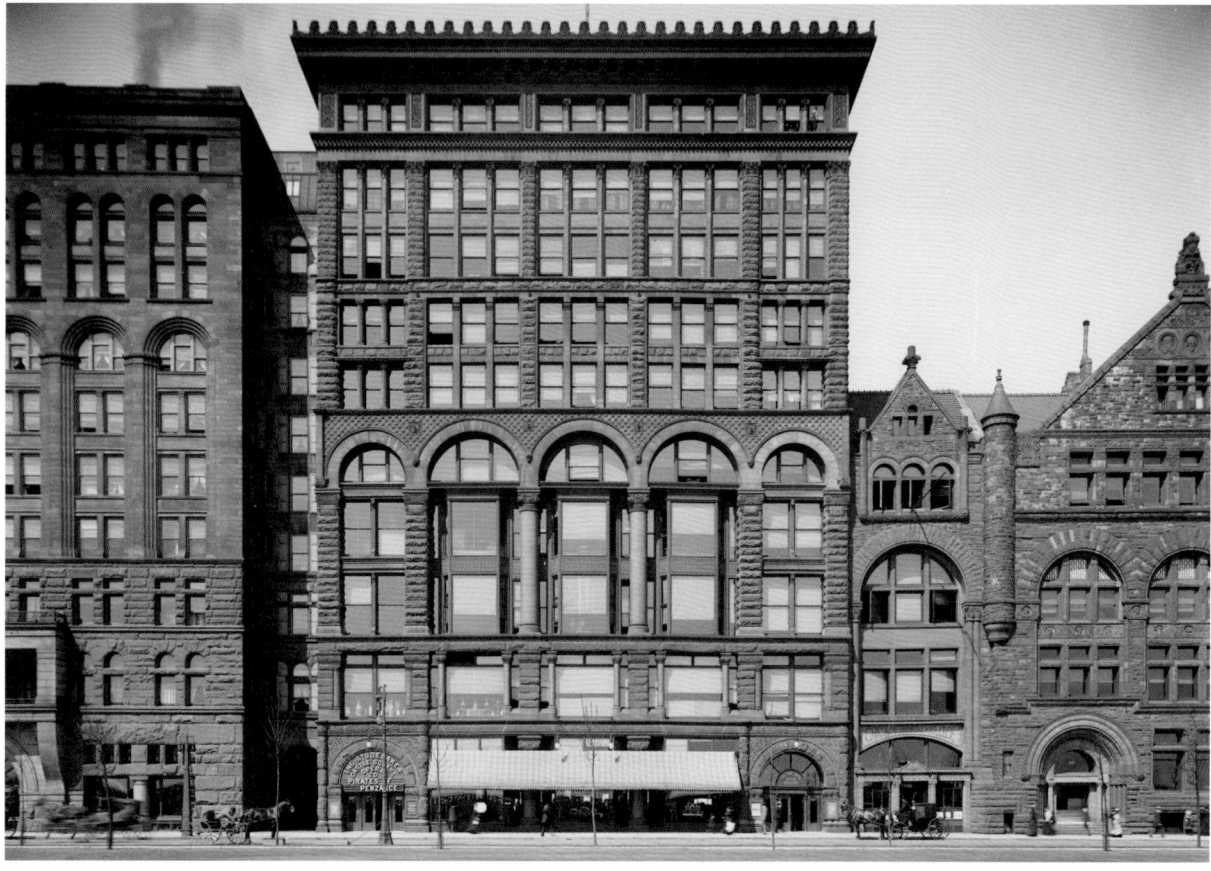

clerked at Field, Palmer, and Leiter (a forerunner of Marshall Field's); kept the books for harp-maker Lyon & Healy (still operating today in the West Loop); managed George F. Root and Sons Music Company; and was president of the Manufacturers Piano Company. He was also instrumental in the conception and construction of the Loop's Weber Music Hall, the first Chicago building devoted exclusively to studios for musicians.

Curtiss knew artist-only spaces could turn a profit. He also recognized the building's prime location in Chicago's developing cultural hub. The Art Institute's new home was just two blocks to the north and the Auditorium Building next door was home to the Chicago Orchestra. The Athenaeum Building around the corner was already home to many fine artists. And South Wabash was Chicago's bustling Music Row, lined with music stores and piano showrooms.

When the entrepreneurial Curtiss pitched the concept of the Fine Arts Building to the Studebakers, whom he knew socially, they bought it. According to the late Chicago historian Perry R. Duis: "His reputation as a businessman helped convince the Studebakers that cultural entrepreneurship could be profitable."

The building's conversion was stunningly swift. Beginning in November 1897, construction crews demolished the ground-floor showrooms, replacing them with two large music halls and several sidewalk-facing stores. They built

FOR BIG MUSIC HALL.

To Remodel Studebaker Building in Michigan Avenue.

WORK TO BEGIN AT ONCE.

Two Auditoriums on Ground Floor Are Planned.

STUDIOS AND OFFICES ABOVE

C. C. Curtiss Expects All to Be Finished May 1.

DISCUSSES DETAILS AND COST.

TOP The Fine Arts Building in 1901, now ten stories tall

ABOVE *Chicago Tribune*, November 12, 1897

| 21 |

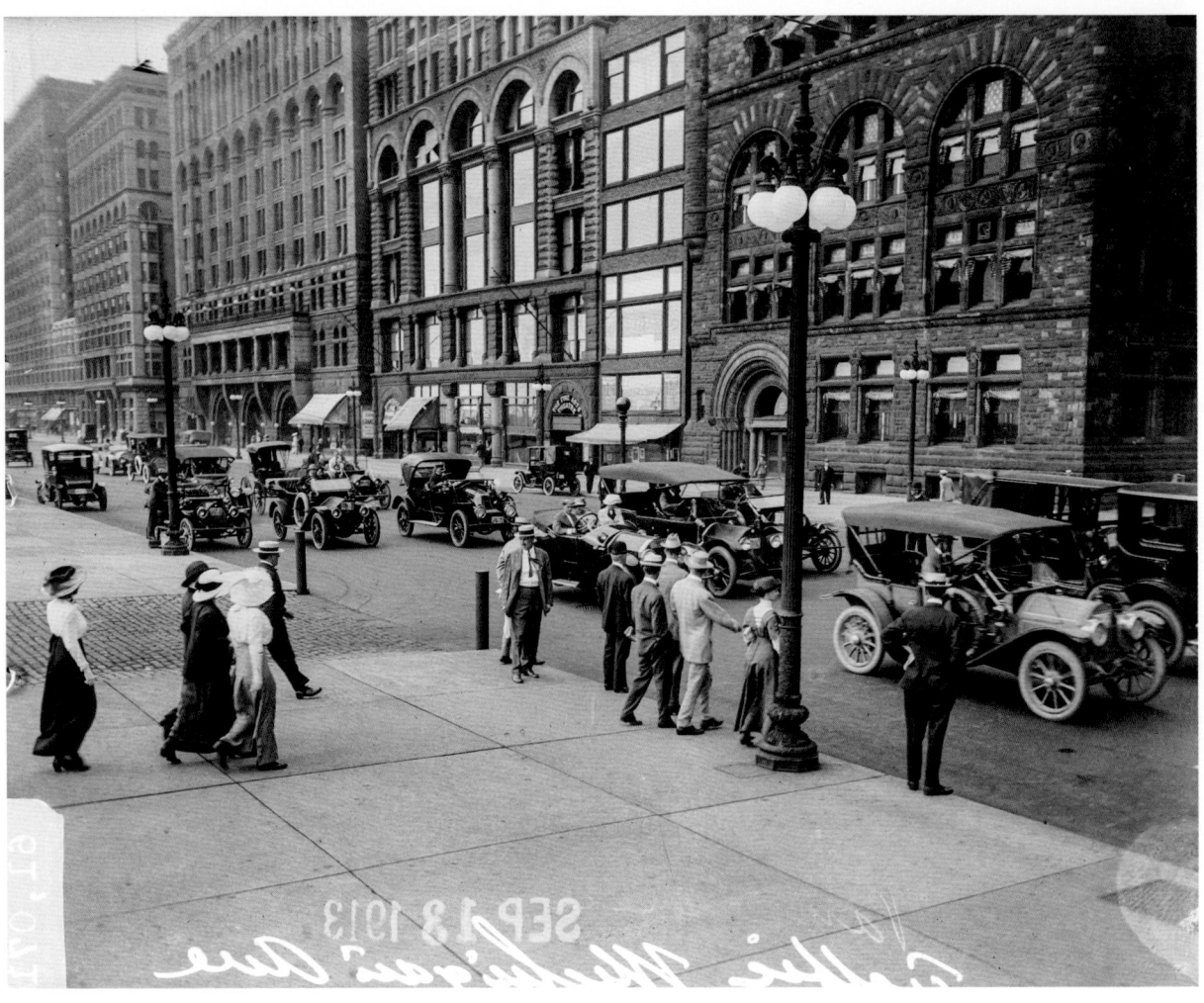

ABOVE Michigan Avenue and the Fine Arts Buidling, 1913

large studios overlooking Michigan Avenue on the second and third floors, and subdivided the higher floors into a warren of studios for arts, crafts, and music, with offices and club rooms, too. The music studios were given extra soundproofing, and throughout, the existing high ceilings and large windows lent themselves to the lighting needs of fine artists. The eighth floor and turreted roof were lopped off and replaced with an additional three stories. The new top floor—the tenth—featured skylights, sliding doors to accommodate oversized artworks, and a banquet hall connected to the Auditorium Building's popular main dining room. Finally, a six-story light well was cut into the center of the building and ornamented according to its new name: the Venetian Court.

When the Fine Arts Building reopened in October 1898, it had been staged to look the part: the lobby was hung with paintings and lined with exhibit cases, while upper hallways were adorned with statuary, ornate benches, palms, and ferns. All told, the $600,000 renovation had cost more than twice as much as the building's original $250,000 construction. But the money had been well spent, both in the eyes of the public and the press. An early review of Studebaker Hall, as the theater was christened, touted it as "the most beautiful music hall ever built."

ACT ONE: A BUILDING REBORN

Curtiss, the building's new manager, had moved in during construction to start the leasing process, but he didn't seem to have had trouble finding tenants. Many artists had recently been forced out of the Athenaeum Building because the commercial school that owned it had a growing need for space. Others, dissatisfied with the facilities in the Masonic Temple, found they could get more room for less money at the Fine Arts Building. Curtiss recruited other desirable tenants, such as noted drama teacher Anna Morgan, whose suite on the eighth floor included a three-room studio and a five-room gymnasium complete with showers and dressing rooms.

Music instruction paid most of the freight. The four-story annex, which had been built in 1889, was immediately occupied by Florenz Ziegfeld's Chicago Musical College (now part of Roosevelt University's College of Performing Arts). The Sherwood Music School (now part of Columbia College) was founded there in 1895, and nearly a hundred individual teachers also moved in. By 1901, more than ten thousand students were taking music lessons at the Fine Arts Building.

In short, the building was a hit. In its first few years, artists and artisans of every kind flocked there: actors, carvers, decorators, dramatists, etchers, illustrators, metalsmiths, musicians, painters, publishers, sculptors, and writers. (Not to mention the odd elocution teacher.) Commerce quickly took root, too, with small retail shops offering everything from books, prints, and pictures, to linens and lace, to antiques, furniture, and pianos.

But it was the best-known artists who put the building on the map culturally. Notable tenants included Chicago's leading portrait painter, Ralph Clarkson; landscape artist Charles Francis Browne; muralist Oliver Dennett Grover; sculptor Lorado Taft; and cartoonist John T. McCutcheon (who would eventually win a Pulitzer Prize). William W. Denslow, who illustrated L. Frank Baum's *The Wonderful Wizard of Oz* (1900) worked next to Ralph Fletcher

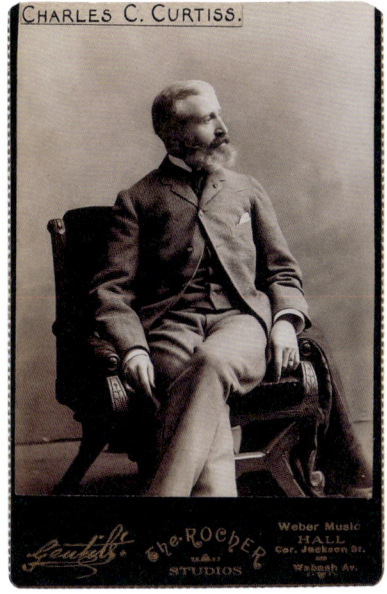

ABOVE Cabinet card photograph of Charles Curtiss

BOTTOM Sculptor Lorado Taft's studio in the Fine Arts Building, 1910

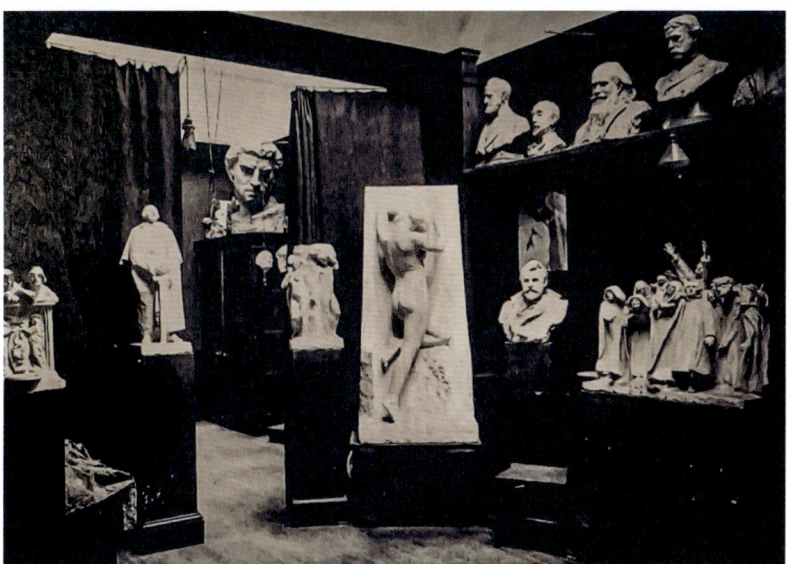

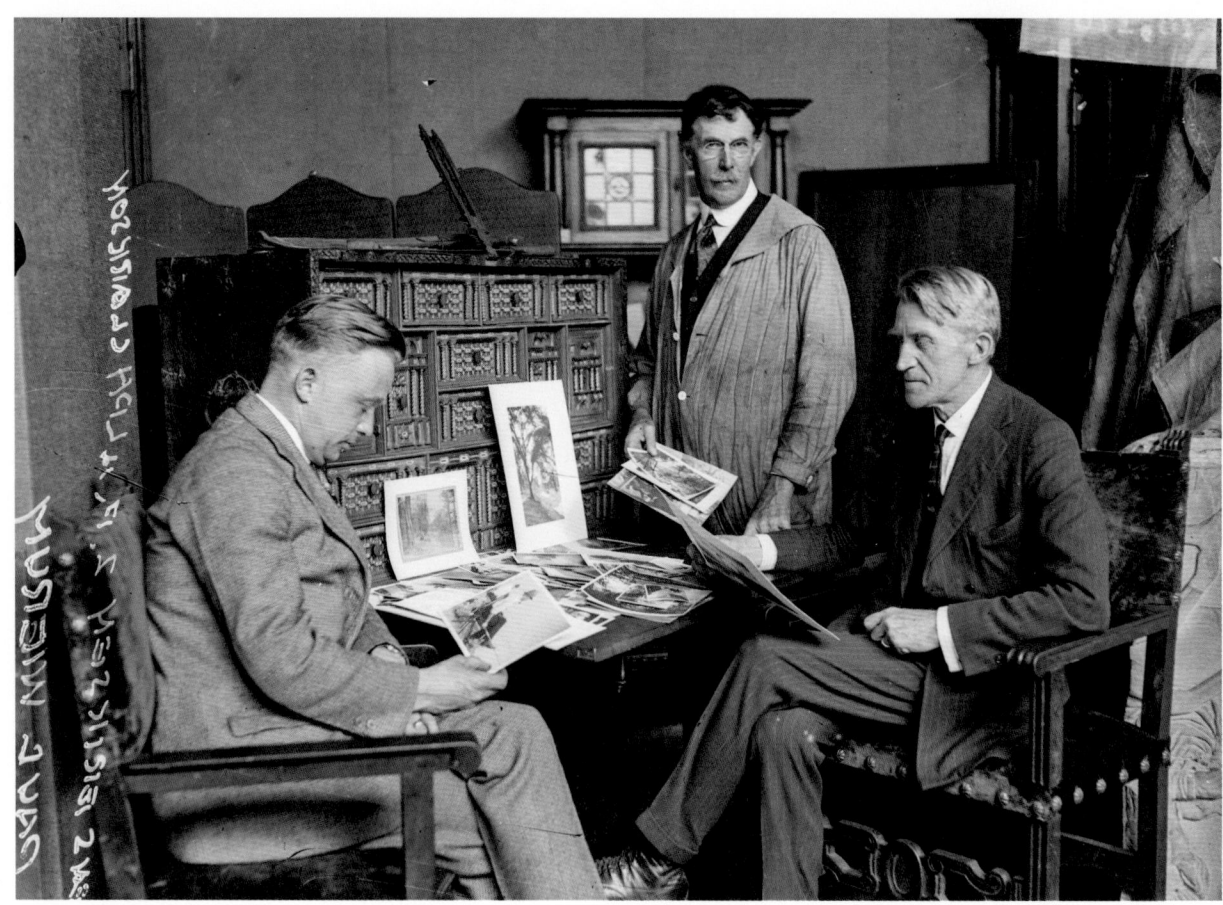

ABOVE Portrait artist Ralph Elmer Clarkson (center) with photographers Jens Eriksen (left) and Paul Weirum (right), 1924

OPPOSITE PAGE Clarkson's studio, also The Little Room meeting place, c. 1910

Seymour, who published Baum and would eventually also publish Henry Blake Fuller's *Bertram Cope's Year* (1919), now regarded as one of the first American gay novels. Fuller, already the author of the then-controversial Chicago classic *The Cliff-Dwellers* (1893), was a frequent visitor to the building and captured the scene on the tenth floor, where many of the most prominent artists had their studios, in his three-novella collection *Under the Skylights* (1901).

But the building's artistic output was not limited to fine and high art. By 1903, twenty editorial publications, many of them mainstream, had offices in the building. Blanche Ostertag arrived from St. Louis to begin her outstanding career as a decorative artist, and German-born commercial artists Frank X. and Joseph C. Leyendecker, the "illustrator twins," had a three-year residency. The Leyendeckers left for New York City in 1901, but not before supervising the creation of eight Art Nouveau panels on the tenth floor. These paintings—mostly classical figures with a fair number of nudes—caused some members of the Chicago Woman's Club to gasp and clutch their lorgnettes when they were first unveiled. Modern visitors to the building can still see the scandalous works for themselves.

Less-remembered artists who worked at the Fine Arts Building include the colorful Lou Wall Moore, or "Princess Lou," a socialite, sculptor, and scandalous dancer; sculptor Alice Cooper; and miniaturist Magda Heuermann.

Any chronicle of a historical art scene risks devolving into a list of names, and yet the names are necessary. They are also necessarily incomplete, a mere fraction of the hundreds who started things and the thousands who would follow. There were other artists' enclaves already in existence around Chicago—most notably, the Tree Studios north of the river—but the Fine Arts Building's choice location and sheer size gave it a gravity that pulled in more talent than any other space.

Community formed organically as artists visited each other's studios or stopped to chat in the halls. The tenth floor was the most prestigious address within the building (the *New York Evening Post* called it "Chicago's Parnassus") and became the home to the "Little Room" club, which Elia W. Peattie described in *The Book of the Fine Arts Building* (1911) as an "insouciant, vagrant academy of folk 'who do things' in a literary or artistic way." (The group had been meeting since 1892 and took its name from a Madeline Yale Wynne short story about a room that appears and disappears by magic.) Its impressive membership list included reformer Jane Addams, humorist George Ade, novelist Fuller, architect Hugh M. G. Garden, novelist Hamlin Garland, cartoonist McCutcheon, novelist George Barr McCutcheon (John's brother), poet Harriet Monroe, drama teacher Morgan, architects Allen B. and Irving K. Pond, illustrator and publisher Seymour, society architect Howard Van Doren Shaw, sculptor Taft, progressive writer Edith Franklin Wyatt—and even Frank Lloyd Wright, who briefly occupied a studio of his own.

The Little Roomers gathered in Clarkson's studio to sip afternoon tea and stage evening performances, discussing issues of the day and indulging a sense of artistic play. (Fuller's *Under the Skylights* included a blatantly satirical portrait of Garland in "The Downfall of Abner Joyce," painting him as a high-minded populist seduced by sophisticated Chicago society. Garland laughed it off—at least publicly.)

ABOVE Library of the Alliance Française, 1917

OPPOSITE PAGE Illinois Equal Suffrage Association members (from left) Mrs. Grace W. Trout, Miss Belle Squire, Miss S. Grace Nichols, and Miss Ella S. Stewart, 1910

In turn-of-the-century America, civic organizations grew like dandelions, and the Fine Arts Building's gathering spaces were used by countless clubs, societies, and charities—many of them also headquartered in the building—from the very start. Between Studebaker Hall and Music Hall on the ground floor, and Assembly Hall (now Curtiss Hall) on the tenth floor, not to mention the individual studios, there was an abundance of options.

Clarkson pressured civic leaders into creating the Municipal Art League, which fostered art appreciation among city dwellers, and its sister organization, the Chicago Public School Art Society. Almost two decades later, in 1916, the Arts Club of Chicago was founded in response to the stodginess of the Art Institute, and after taking up residence in the Annex, it promptly sponsored an exhibition of work by "artistic anarchists." The Chicago Literary Club, the Caxton Club, the Chicago Kindergarten Association, the Amateur Musical Club, the Alliance Française, the Theatre Française, the Young Fortnightly, the College Club, the Wednesday Club, and the Thursday Club are just a few of the arts and social clubs that called the Fine Arts Building home.

It is also a notable site for women's history, both in art and politics. "Here, too, meets the Fortnightly, the oldest of the women's social and literary societies

ACT ONE: A BUILDING REBORN

in Chicago—an organization of Brahmin caste, with a high reputation for its literary product," wrote Peattie, describing the high-toned cultural and self-improvement association that had been founded in 1873. Notable for early members such as Addams, Bertha Potter, and Monroe, the Fortnightly moved into the Fine Arts Building and remained there until relocating to a Gold Coast mansion in 1922.

The Cordon Club was founded there, after the Cliff Dwellers, a male-only arts club founded by Garland and headquartered in the attic of Orchestra Hall, scorned sculptor Nellie Walker's request to add a women's division. By the time of the Cordon Club's first meeting in 1915, membership had been capped at four hundred with a lengthy waiting list. The group met on the eighth floor behind two massive doors beautifully carved by Walker herself. The social club was notable for the fact that its socialites were balanced or even outnumbered by professional women. Addams, Morgan, and Monroe graced the roster of this club, too—the building must have felt like a second home to them.

The Fortnightly and Cordon members largely left politics and religion outside their doors, but many other organizations did not. The Fine Arts Building would become a hub for women's groups both on the rearguard (the Colonial Dames, the Daughters of the American Revolution, and the Catholic Women's League) and in the vanguard (the progressive Chicago Woman's Club and the Illinois Equal Suffrage Association).

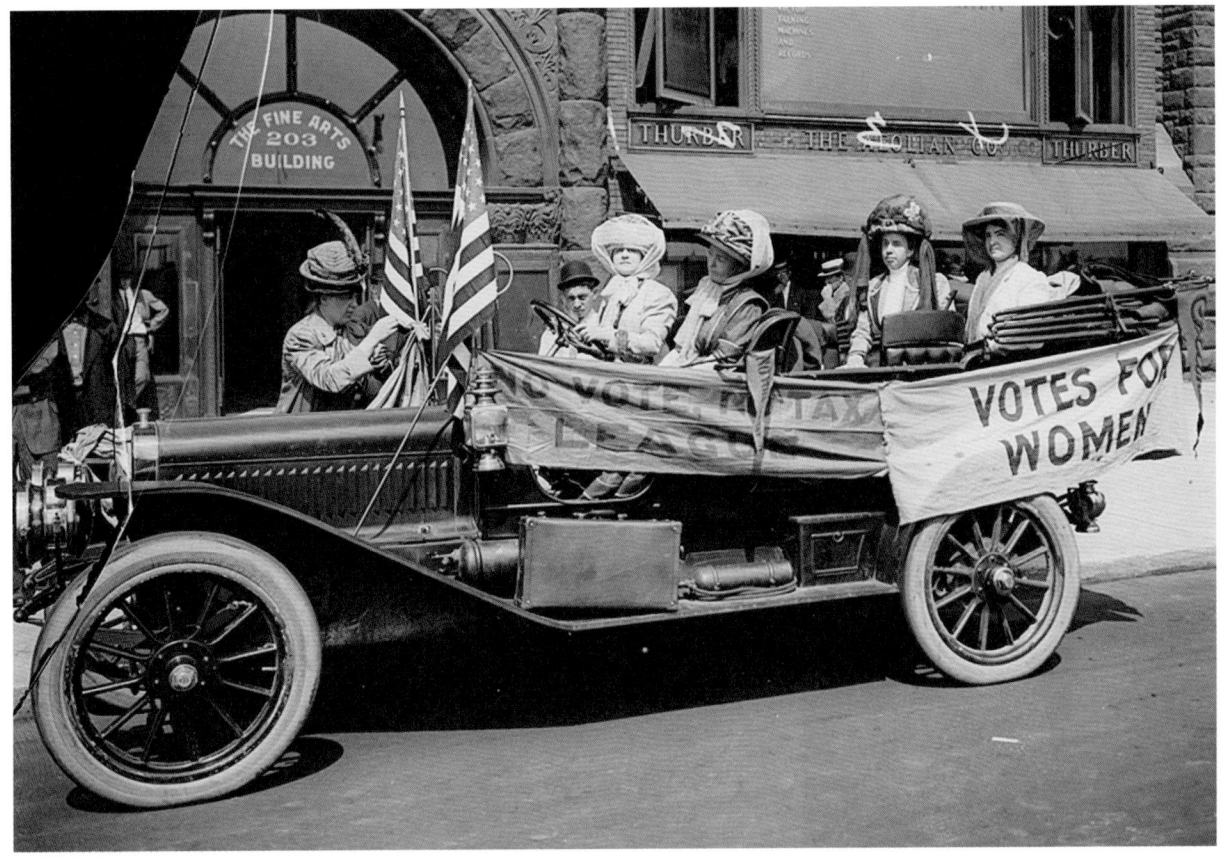

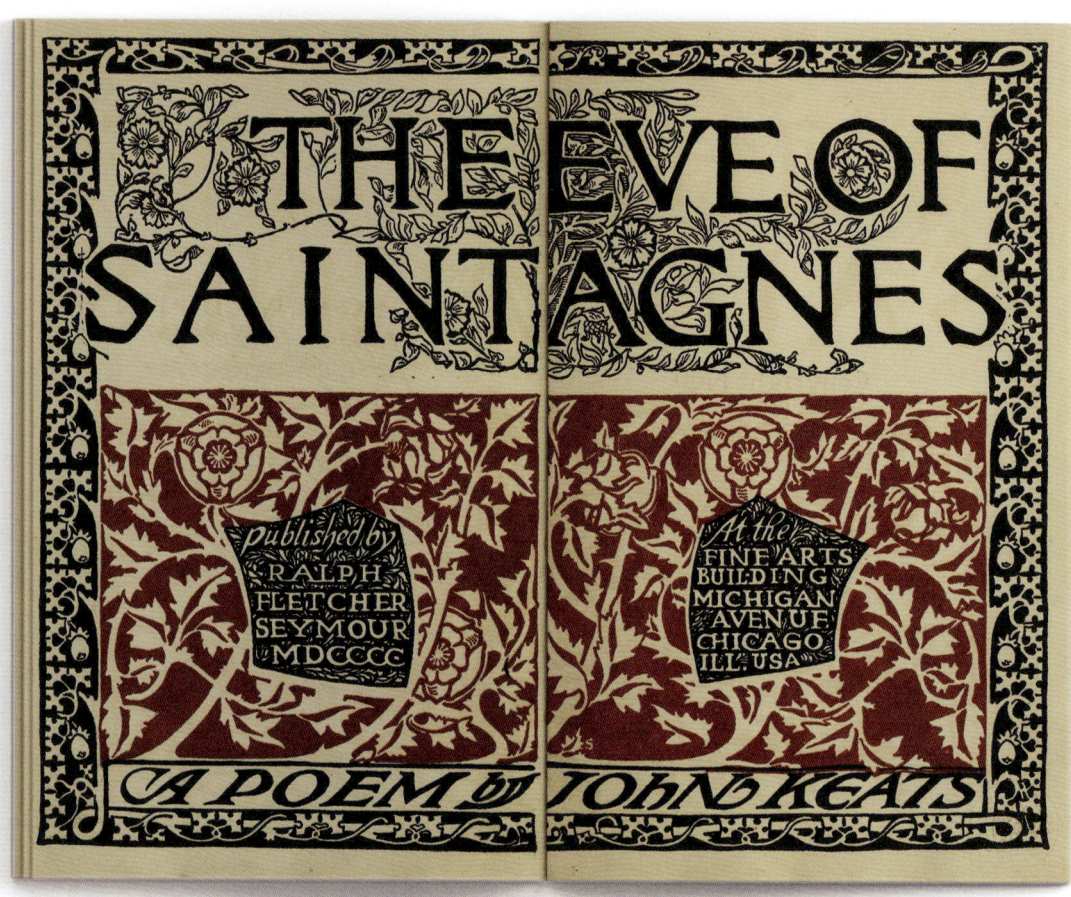

ABOVE Book illustrated and published by Ralph Fletcher Seymour, 1900

OPPOSITE PAGE, TOP Dancer Isadora Duncan

OPPOSITE PAGE, BOTTOM Studebaker Theater audience, 1910

The building was also at the center of a burgeoning arts and crafts movement, particularly in book art and bookbinding, the latter an activity encouraged for young women. Seymour produced high-quality limited editions of illustrated books. The bibliophiles at the Caxton Club published limited-edition volumes in the Arts and Crafts style. Other book artists included W. Irving Way, whose studio specialized in hand-illuminated books, bookbinder Gertrude Stiles, the Golden Bindery, and the Rose Bindery, where Mrs. Hobart C. Chatfield-Taylor trained young women to make fine-leather book bindings.

Handicrafts, whether made in the Fine Arts Building, elsewhere in Chicago, or across the sea, were sold in wild profusion. In addition to the bookbinders, silversmiths, and photographers, there were shops selling cushions, table covers, screens, decorated china, and copper lamps and lighting fixtures. The Norwegian Shop and the Irish Shop sold transatlantic imports. At the Wilro Shop, Minnie and Rose Dolese sold Swedish weavings and decorated leather card cases, belts, pocketbooks, and other accessories. The Kalo Shop sold burnt and embroidered leather goods before turning to the hand-wrought silver tableware and jewelry for which it's remembered today. At the T. C. Shop, Emery W. Todd and Clemencia C. Cosio made silver serving, dining, and flatware. The unfortunately named Swastika Shop offered handmade lighting devices, silver bowls and tableware, jewelry, and old copper, brass, and silver. Pratt Studio set stones for the wearer.

As the crafters evolved from single-purpose shops to multi-craft cooperatives, they staged joint exhibitions before forming, in 1910, the Artists' Guild, a five-room co-op store on the fifth floor. A year later, with 128 members, they opened the Fine Arts Shops. Then in 1915, they took over the Annex.

The activity in the Fine Arts Building's early decades beggars the modern imagination. Isadora Duncan danced on the stage of the Studebaker. Society people took tea at the seventh-floor Browne's Bookstore, designed by Wright—who also designed the fifth-floor Thurber Art Galleries a few years later. Browne's was the brainchild of Francis Fisher Browne, editor of the conservative literary journal, *The Dial*, which was published on the same floor. Monroe founded *Poetry* there (printing "The Love Song of J. Alfred Prufrock," T. S. Eliot's first professionally published poem, in 1915) and Margaret Anderson founded *The Little Review* there, too (serializing James Joyce's *Ulysses* beginning in 1915). The Chicago Kindergarten Institute opened the Children's Book Store, one of the first bookstores catering exclusively to kids. The Marx Brothers brought their vaudeville act to the stage of the Studebaker.

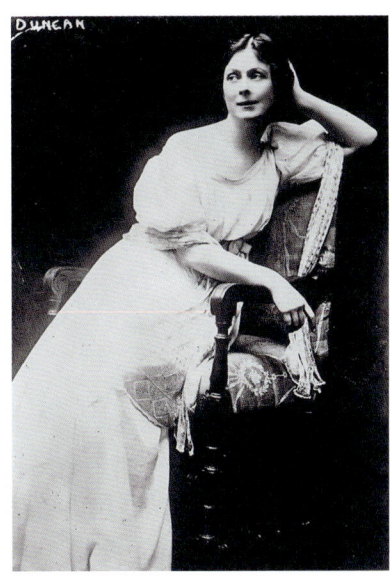

As Chicago architect David Swan put it in his introduction to the facsimile edition of *The Book of the Fine Arts Building* (1911; 2008), "For Charles Curtiss, the completion of the Fine Arts Building was the culmination of a fifteen-year dream to create the ideal conditions for centralizing the artistic, social, and literary concerns of the city into a single building . . . As was noted just a year after the Fine Arts Building had opened, Curtiss had been instrumental in assembling under the roof of the Fine Arts Building 'all that is best of the best side of Chicago life.'"

But the golden years were about to end.

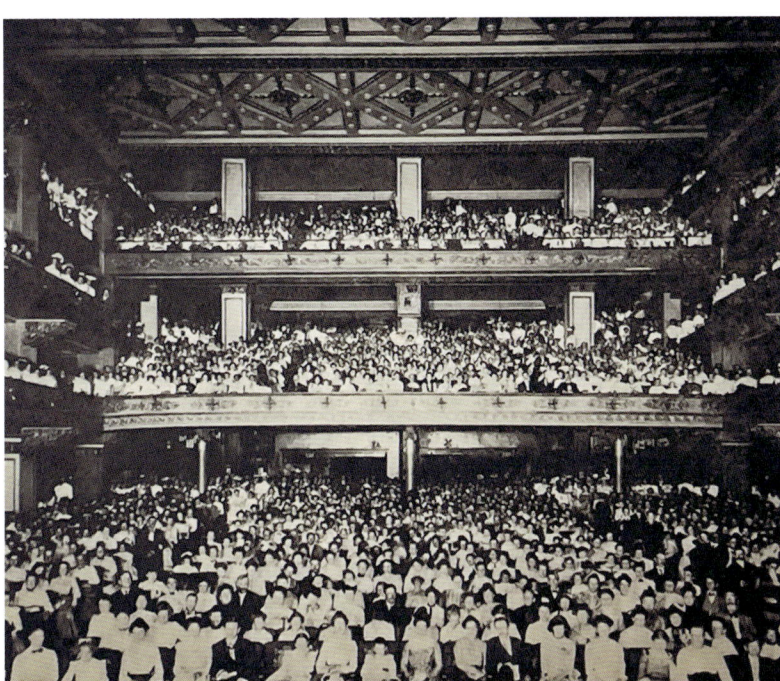

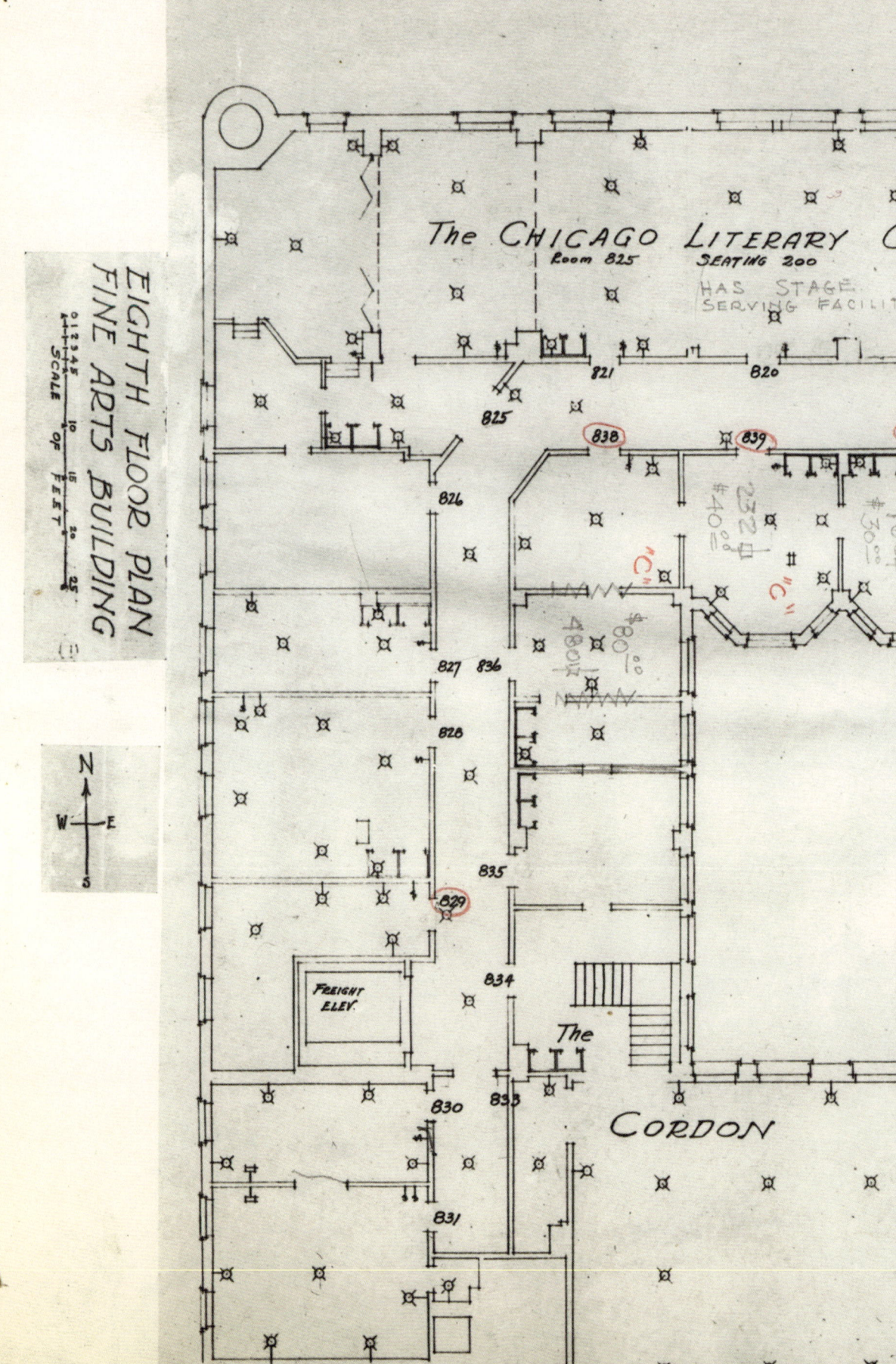

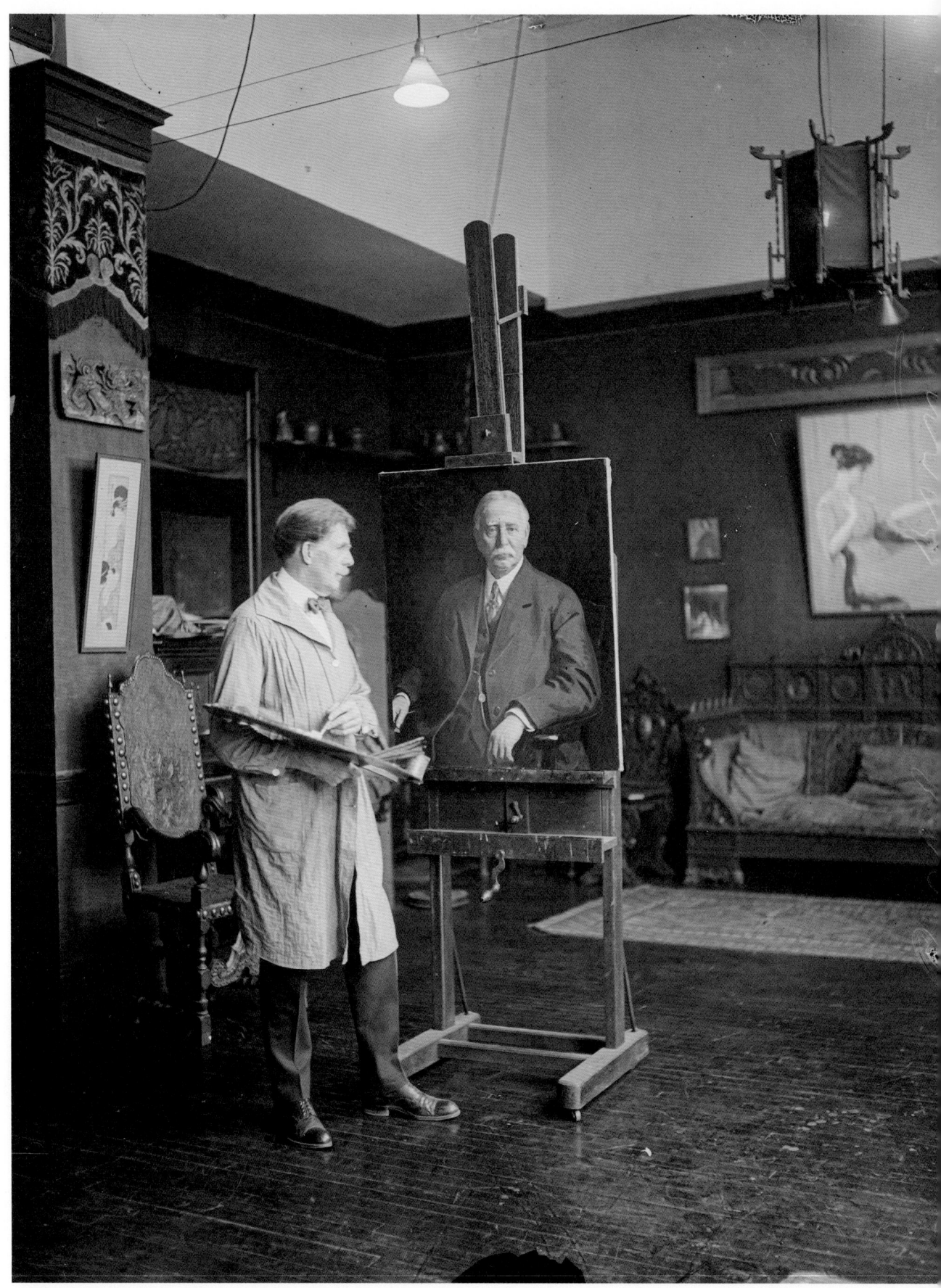

ACT ONE: A BUILDING REBORN

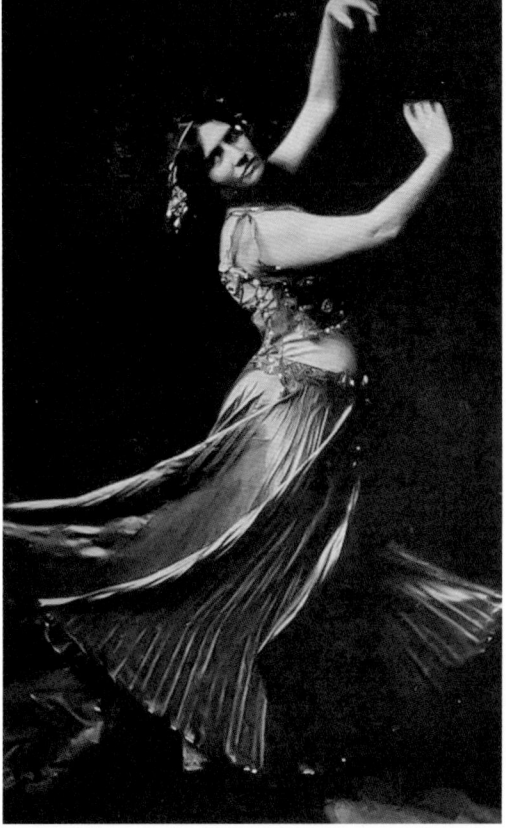

FROM TOP, CLOCKWISE Frank Xavier Leyendecker, c. 1921; Lou Wall Moore, 1908; W. W. Denslow, 1900

OPPOSITE PAGE Ralph Clarkson in his studio, c. 1924

PREVIOUS SPREAD Plan of the eighth floor, 1900

| 33 |

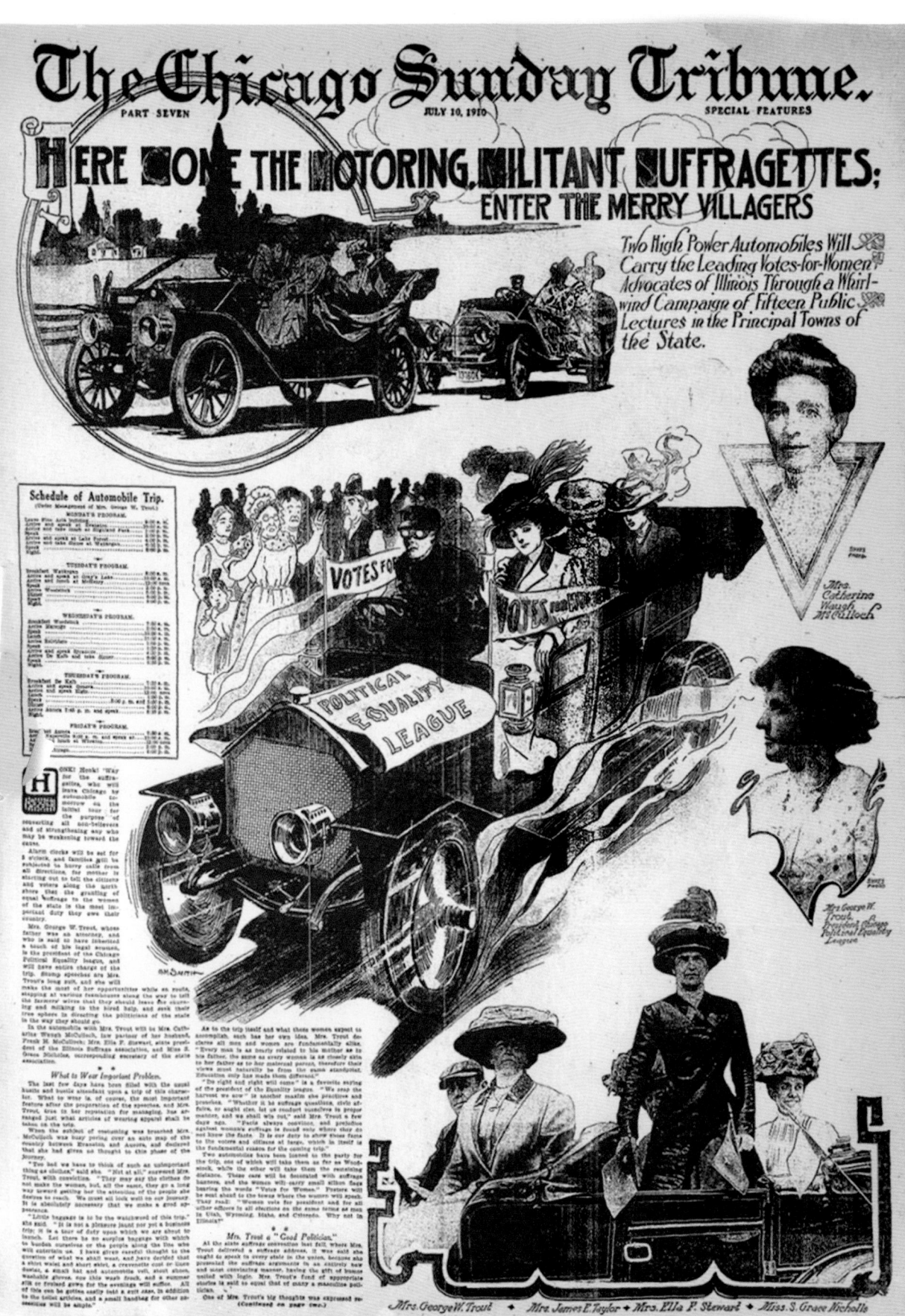

ACT ONE: A BUILDING REBORN

ABOVE Suffragettes (from left) Miss Belle Squire, Mrs. Grace W. Trout, Miss S. Grace Nichols, and Miss Ella S. Stewart in front of the Fine Arts Building, 1910

OPPOSITE PAGE The *Chicago Sunday Tribune*, July 10, 1910

| 35 |

ACT ONE: A BUILDING REBORN

FROM TOP LEFT, CLOCKWISE Designed by Frank Lloyd Wright, 1908: Front cove of Browne's Bookstore; front door and cash register of Browne's Bookstore; fireplace in Browne's Bookstore; W. Scott Thurber Art Galleries

OPPOSITE PAGE Whitney art studio, 1918

FROM TOP LEFT, CLOCKWISE Arrow Shirt Collar advertisement by J. C. Leyendecker, 1907; "Harem Scene" by Oliver Dennett Grover, 1899; landscape by Charles Francis Browne; "Nouvart Dzeron, a Daughter of Armenia" by Ralph Elmer Clarkson, 1912

ACT ONE: A BUILDING REBORN

FROM TOP LEFT, CLOCKWISE Illustration from L. Frank Baum's *The Wonderful Wizard of Oz* by W.W. Denslow, 1915; "Orpheus Consoled" by Lorado Taft, 1915; "Road hogs" by John T. McCutcheon, 1922; bookplate designed by Ralph Fletcher Seymour, 1936

| 39 |

INTERLUDE

Chicago's Citizen Kane

INTERLUDE

SAMUEL INSULL WAS THE MOST POWERFUL MAN IN CHICAGO DURING THE EARLY TWENTIETH CENTURY. The fanatically focused Englishman had started out as Thomas Edison's secretary before becoming his business manager, providing steely-eyed business acumen as he manufactured and marketed the many inventions Edison had patented. But he craved more, and when the president of the Chicago Edison Company died in 1892, Insull nominated himself for the role. He quickly demonstrated his talent for playing utility monopoly, building his dominance with Commonwealth Edison and People's Gas, Light & Coke Company until he controlled power plants, gas companies, and interurban railways in eight Midwestern states. His empire generated sums in the Roaring Twenties that are staggering today even before they're adjusted for inflation. (From the Fine Arts Building, John T. McCutcheon caricatured him as a dour desk jockey commanding his empire by push buttons and telephone.)

INTERLUDE: CHICAGO'S CITIZEN KANE

During his rise, Insull had been smitten with an actress, the possibly teenage ingénue Gladys Wallis (real name Mary Bird), whom he had first seen onstage. Wallis was so tiny—barely five feet tall and weighing less than one hundred pounds—the papers called her "a pocket Venus." After they were introduced at a dinner party, the decade-and-a-half-older Insull courted Wallis. Either despite their age difference or because of it, he proposed, and they were married in 1899, upon which she promptly retired from acting.

Over the next several decades, Wallis, who'd taken Insull as her married name, became a society doyenne, presiding over a Gold Coast apartment, an estate in suburban Libertyville, and social functions where the assembled jewelry frequently valued in the millions. Her hands and feet were so small that her gloves and shoes were custom-made—as were the diamond and emerald bracelets she wore, as many as ten at a time. By most accounts, Wallis was beloved neither in society nor at home and the marriage was cold and brittle as the wife frequently reminded her husband she had given up her performing career for him.

When her only child, Samuel Jr., graduated from Yale in 1925, Wallis decided to leave her empty nest for the floodlit stage. To indulge her, Insull financed a

SAMUEL INSULL TO WED.

MISS GLADYS WALLIS, THE ACTRESS, WILL BE THE BRIDE.

President of the Chicago Edison Company Admits the Betrothal and Says the Marriage Will Take Place Soon—Rumor Puts the Date in June and the Place in New York, Where the Trousseau Is Now Being Purchased.

TOP *Chicago Daily Tribune*, May 20, 1899

LEFT & ABOVE Gladys Wallis, age 18, 1893

OPPOSITE PAGE Samuel Insull on the cover of *Time Magazine*, November 1926

PREVIOUS SPREAD Political cartoon by John T. McCutcheon, 1925

| 43 |

revival of Richard Sheridan's *The School for Scandal* as a benefit for St. Luke's Hospital, whose board was a who's-who of Chicago. No expense was spared: the limousines of arriving city elites passed under a canopy of blazing orange and green electric light bulbs said to be three blocks long. The Armours, the Marshall Fields, the Pullmans, and the Drakes all witnessed fifty-six-year-old Gladys Wallis' star turn as the coquette, Lady Teazle.

After the two-week run raised $125,000 for St. Luke's, the reinvigorated Wallis resolved to pick up her career where she'd left off. She took her act to Broadway, with Insull as her producer, but her reception on the Great White Way was poor. "This play has been pre-empting Little Theatre for weeks by weight of money and without question of merit," sniped the *New Yorker*. "It will probably cost Insull $100,000 loss, to keep the play going, but Mrs. Insull is having her fun."

Wallis soon returned home to Chicago, undaunted, and planned further theatrical adventures. Insull objected to her travels, and as a compromise financed the Repertoire Theater Company, to be based in the Fine Arts Building's Studebaker Theater. An August 1, 1926, press release proclaimed that its offerings—new plays by American authors with selected revivals of popular works—would be "on the same level as New York's best." Showing either faith in her ambition or dogged determination to save his marriage, Insull leased the Studebaker for five years. The company's premiere effort, Gretchen Damrosch's *The Runaway Road*, was generally well received, but the second play, in which Wallis once again played a gamine, was a disaster. The comical miscasting was seized upon by the press, who also savaged the rest of the cast. Facing reported losses of $1,000 per day, the company quickly ended the season, citing an unspecified illness suffered by their star performer.

But the Insulls were not done. Wallis tried again to reverse the company's fortunes, this time by recruiting the legendary Alfred Lunt and Lynn Fontanne to bring their Theatre Guild to the Studebaker. Lunt and Fontanne's six performances played to raves and full houses, but that good feeling was not transferable. Wallis' next two plays (George Bernard Shaw's *Heartbreak House* and A. A. Milne's *Mr Pim Passes By*) took critical and financial drubbings. In December, Wallis finally admitted defeat. "I have reluctantly reached the belief that my ambition was misdirected, my money wasted," she announced. The following month the Repertoire Theater Company officially folded.

TOP & OPPOSITE PAGE Newspaper headlines featuring Mrs. Insull, 1925–1927

ABOVE Playbill for *The School for Scandal*, 1925

Mrs. Insull's Costly Failure To "Come Back"

And Why Her Husband Is Believed to Think the $200,000 He Spent on Her Try at a New Stage Career Money Very Profitably Invested

Mrs. Insull and Frederick G. Lewis, as they appeared in the play called "Dice of God." This was the role for which Mrs. Insull's son and other critics thought she was "not tough enough"

On the left, Mrs. Insull in "The Runaway Road"

Mrs. Samuel Insull, the rich and fashionable society woman, whose attempt to resume the stage career she abandoned when she married was far from the success she hoped

SOME twenty-five years ago, when Samuel Insull, Chicago public utilities magnate, married a pretty little soubrette, named Gladys Wallis, a part of the marital poet was that Gladys Wallis should not longer exist. And for a quarter of a century the name of Gladys Wallis was unheard. Pretty, petite Mrs. Samuel Insull was busy looking after the home of the man who had risen from pot-hooks to power-lines, getting established in Chicago society and rearing her son, Samuel Insull jr.

Chicago society, which now includes Mrs. Samuel Insull in its little black, red-lettered social register, was shocked had fall by the announcement of the return to the stage of the wife of its traction and public utilities magnate, its opera head. The preliminary shock was repeated when large, black-lettered poster's announcing "Mrs. Insull's Season" blossomed all over the city.

Tongues clacked. Mrs. Insull was tired of being only Mrs. Insull. Her husband had a life of his own, and here the name of an opera singer or two was mentioned. She was going to have a little self-expression of her own.

As has been said, tongues clacked, but on the opening night of Mrs. Insull's appearance at the head of her own repertoire company, society was there, gowned in its best and flashing with jewels, to welcome Mrs. Insull, to applaud, and to watch with curious eyes the expression of the white-haired, rubicund Sam Insull, in the third row, with his son.

Mr. Insull had been dead set against the project, gossip said. But he smiled affably, even when his wife made stage-love to another man, applauded generously, and made tactful replies to glowing comments after the performance.

The clucking tongues stopped for a time, but when, after two months and a half of operation, announcement was made that Mrs. Insull's theater project was to terminate on January 15, they broke out again. Gossip in theatrical circles was that Mrs. Insull's repertoire theater company had been operating under a thousand-dollar-a-day deficit.

Gossip in social circles was that the wise and canny millionaire, who had risen from stenographer to magnate, and who also knew something about art and temperament, knew the venture would be a "flop," but thought it cheap at a reputed $200,000 loss, if his wife is cured of her desire to be an actress.

Whether she is or not, only time will tell, but it is believed that Mrs. Insull will give up her project to establish "a permanent dramatic organization for Chicago to offer worth-while plays that will enlist attention on its merits."

The Studebaker Theater was leased by Mrs. Insull's organization for five years. The sum of $80,000 was paid for the lease, and the rent was $85,000 a year. When the notice of termination of the 1926-7 season was made public, it was announced that the company's season will begin again next October.

This, too, was regarded as doubtful along the Rialto and among Mrs. Insull's friends.

That the pretty little lady, with the dark eyes and the beautiful teeth, has spirit and grace, her audiences do not deny, nor that she acts her part well. But they say that she lacks that magnetism, that charm that has a pulling power across the footlights.

"She is a mechanical actress," said one critic. "She goes through her part with spirit and charm, but it remains a part."

Mrs. Insull's opening production was "The Runaway Road." Her personal triumph lacked nothing apparently, with many recalls, floral tokens, much applause, responsive laughter, and out in front her smiling husband and frankly adoring son. An awning and a red carpet from curb to entrance, and masses of flowers added to the gala note.

Although the audience was made up of the cream of Chicago and Lake Forest society, friends of the Insulls, it came, too, as a critical lady to be "shown." And it was won by Gladys Wallis's spirit and charm. That was November 1.

After the first night, the audiences were fairly good, and Chicago society became accustomed to having pretty Mrs. Insull dash away from teas or luncheons for a rehearsal, or refuse dinner invitations because of an 8 o'clock curtain. It became accustomed, too, to her empty box at the opera, particularly conspicuous on the opening night, when Mr. Insull, as head of the Chicago Civic Opera Company, was an important figure.

But when the second production appeared, "The Dice of God," things did not go so well. Young Samuel Insull jr., seated in the front of the theater with his bride, the former Adelaide Pierce, and his father, unwittingly summed it up.

"Oh, mother's not tough enough," he commented, as he watched his mother go through her role of a Paris gamin.

He was right. Mrs. Insull wasn't tough enough. She wore her short, perky cheeks, skirt, her sleeveless satin blouse, her gamin-like hat with the quills stuck through, as she might have worn a masquerade costume. She wasn't really Marie, the street gamin.

Underneath the clothes of Marie she was still pretty, petite Mrs. Samuel Insull, so at home behind a silver tea-urn, so gracious in her own drawing-room on Lake Shore Drive, with the bronze of Duse on the table and the antique Chinese chests in the hall.

As the play progressed and Marie's gamin-like ways were tamed by her love for Jean, the society-actress became more real. She showed fire and abandon, and the critics who wanted to be most kind to her could only say that her acting "showed a real talent for the stage."

Mrs. Insull's preliminary return to the stage was for the sake of charity. She appeared in Sheridan's "The School for Scandal," in behalf of the St. Luke's Hospital building fund.

She was a "hit," and the actress who had been carried off from the footlights to become the chatelaine of a rich man's home, knew again what it meant to sense an audience, to be the cynosure of thousands of eyes, to go through a dramatic role.

After the series of benefit performances in Chicago closed, Mrs. Insull took the play to New York and for a month charmed Broadway audiences by her playing of the role of Lady Teazle. Herbert Druce played the part of Sir Peter to Mrs. Insull's Lady Teazle, and Beatrice Terry was Lady Sneerwell.

When, a short time after the close of the Broadway run, announcement was made that Samuel Insull had leased the Studebaker Theater for his wife, Mrs. Insull herself issued a statement in which she outlined what she was aiming to do.

"I am aiming to give Chicago good plays, well cast by the best available professional talent," she said. "What I would like to make clear is that this venture is not a fad, nor is it an effort to uplift the stage, and I can assure you it will not be highbrow or exclusive Just theater. Just entertainment, that is our goal.

"I have been asked how I happened to go into this new venture. I can only answer that I wanted to do something worth while. I detest idleness. If I could paint I would probably have parchased a box of colors, taken a studio and painted, but I can't.

"I believe in self-expression, and I naturally turned to the theater, my early calling. My return to the stage came about, I fancy, through my appearances in the 'School for Scandal' last year. The public seemed interested, and I wondered if a first-class professional organization in Chicago and for Chicago would not have a public appeal. Thus it came about that the Repertoire Theater Company, an Illinois corporation, was organized and the fine Studebaker Theater taken over for a term of years.

"In appearing at the Studebaker, personal exploitation is farthest from my mind. The ensemble presentation of the play is what counts and not whether I, or some other member of the company, have the chief role. The idea got abroad at first that we were going to do freak plays. Of course, that is not the case at all.

"Plays are hard to get, plays that the public will go to see, but that is the sort that we are after. I trust I am broad-minded and I appreciate that the stage must reflect real life to be interesting, but that is not sufficient reason to dramatize the low and vulgar things of life—a tendency I am sorry to see creeping into the American theater.

"The average man or woman wants to go to the theater to be entertained—not shocked. I hope our enterprise will be understood by Chicago theatergoers and that what we do will merit their approval."

Mrs. Insull's company disbanded January 15 and returned to New York. And in the final summing up of her efforts to start a permanent repertoire company, she is given credit, among other things, for producing the plays of two new playwrights.

The first play, "The Runaway Road," was by Gretchen Damrosch Finletter, daughter of the famous Walter Damrosch. The second play, "The Dice of God," was by James Joseph McGinnis.

And Samuel Insull, one of the important men of America, who was once Thomas Edison's office boy, and who now controls Chicago's rapid transit system, its public utilities and its grand opera, is well satisfied with his loss of a handful of his thousands.

Many other wealthy husbands probably would be glad to spend as much or more in order to cure their wives of their desire to express their artistic selves on the stage or in grand opera or in a painter's or sculptor's studio.

Those who thought that Mr. Insull was setting a bad example for other restless women by encouraging his wife's theatrical ambitions have changed their minds. They now realize that he was as shrewd and far-sighted in handling this domestic situation as he is in handling gigantic financial deals. He seems to have come off the victor by pretending to admit his defeat and backing Mrs. Insull's plans with princely generosity.

When Mrs. Insull and her high-salaried company of players ended their recent disastrous engagement in Chicago it was announced that they would be seen on the same stage again next fall. But it is suspected that this was only a graceful gesture on her manager's part.

After the discouragement of playing for weeks to such large banks of vacant seats, it is hardly believed that the millionaire's wife will make another attempt to "come back" as an actress.

Even more disheartening than the poor attendance were the comments of the critics who kindly but frankly pointed out the society woman's limitations and her unfitness for the roles she attempted.

Of course, Mr. Insull's lease of the theater be provided for his wife still has four years to run. But that's a trivial matter for a man of his wealth. Perhaps, in view of what happened to Mrs. Insull's venture, some other millionaire, with a theatrically ambitious wife, will take over the lease.

ABOVE Samuel Insull on the witness stand, c. 1934

Insull declared himself "out of the theater business" but was unable to break his contract with the Studebaker. The banks handling his affairs were still paying the lease in 1932 when his tottering business pyramid—he had stacked companies into holding companies financed by the sale of securities—finally collapsed under its own weight. For three hours he sat at his desk signing resignations as chairman, director, and president of his companies. One newspaper called him "The World's Greatest Failure," noting that it had taken him only fifty days to lose what had taken him fifty years to build.

INTERLUDE: CHICAGO'S CITIZEN KANE

ABOVE Newspaper headlines, 1932

BELOW The throne-inspired Civic Opera Building, c. 1930

Urban legend, frequently repeated by Chicago tour guides, holds that the Civic Opera House, financed by Insull, had been built for Wallis, and the reason its chair-shaped design faces west was her rejection by New York's Metropolitan Opera. None of it is true: Wallis was no opera singer, and its construction began in 1927, one year after her second retirement from the stage. It may be correct, as some have said, that Insull refused to rent space to anyone in the arts there—though that could simply have been a business decision.

Wallis' New York snubs were immortalized in one of the greatest movies of all time, however. When *School for Scandal* played New York in 1925, Herman Mankiewicz, then a young drama critic for the *New York Times*, was assigned to review its opening. He hated it, but after getting drunk before, during, or after the production (likely all three), he was in no shape to write his review. When he returned to his desk, he had only managed to type the lede ("Miss Gladys Wallis, an aging, hopelessly incompetent amateur") before passing out at his desk. Senior drama critic George Kaufman probably finished the review.

Fifteen years later, hired by Orson Welles to write what would become *Citizen Kane*, Mankiewicz used this scenario and embellished it. Charles Foster Kane has a talentless young wife, Susan, for whom he builds an opera house. When she performs in it, her ineptitude is revealed, and Kane's friend, Jedediah Leland, is assigned to review it—but collapses before he can finish his savagely honest critique.

The incident may have been fictionalized in *Citizen Kane*, but in real life, the Fine Arts Building is where it all fell apart.

| 47 |

ACT

Art
Colony in
Decline

TWO

ABOVE Michigan Avenue and the Fine Arts Building, c. 1926

ACT TWO

WHEN CHARLES CURTISS DIED ON MARCH 26, 1928, HAVING MANAGED THE FINE ARTS BUILDING ALMOST UNTIL HIS DEATH, ITS SUCCESS MUST HAVE EXCEEDED HIS WILDEST IMAGININGS. His creation was not just a home for Chicago's working artists and artisans but a performance showplace, the city's most popular destination for musical instruction, and a hotbed of intellectual ferment where artistic ideas and social movements were born. And it was profitable, too.

But there were signs the building's influence was beginning to wane. Many of the more bohemian artists had already moved out, some forming an urban art colony on 57th Street centered around two leftover concession buildings from the World's Columbian Exposition of 1893. Others relocated to spaces on the Near North Side, including the Tree Studios on Ohio Street and the Newberry Library on Walton Street. Music teachers were leaving, too. The numbers told the story: in 1903, the Fine Arts Building counted thirty-one artists and ninety music teachers; in 1927, the numbers had fallen to seventeen and forty-four, respectively. Lorado Taft had departed in 1910. The *Little Review* was gone. The Little Theater was no more. Indeed, many of the most famous tenants had left by the mid-1920s—some of them a decade before.

ABOVE Tenth-floor murals and skylights
OPPOSITE PAGE Henry Blake Fuller, c. 1896

Then, in October 1929, the Great Crash ushered in the Great Depression and the building began a long, slow decline. Patrons had less money to commission arts and crafts. Middle-class Chicagoans had less money with which to buy them. Artists found it harder to pay rent on studios. The Fine Arts Building became a less fashionable address as the excitement of its early years faded. Even the Little Room finally disappeared for good in 1931.

In the early days, when newspapers still chronicled comings and goings at the Fine Arts Building, one journal called it "the first art colony of Chicago." At a time when artists were drawn to the building almost by sheer force of gravity, it's easy to see how the idea took root. The phrase has been repeated so often, it's accepted as truth. NPR referred to the building as "a vertical arts colony" and it's featured in Keith M. Stolte's book, *Chicago Artist Colonies* (2019), which uses an admittedly "elastic" definition. The building's own marketing materials incorporate that claim. In an article about the building's 125th anniversary, the *Chicago Tribune* went even further and called it "a vertical art colony and a commune and a sanctuary and a crucible."

But by most accepted definitions, it's not an art colony. Historically, art colonies were spontaneous gatherings of artists, often in rural areas, seeking peace and quiet in which to work. Sometimes they coalesced around a mentor or a movement. Today, they are most often structured as nonprofits offering residencies—usually in the company of peers, usually in a bucolic setting—where creators are given time to focus on thinking deep thoughts and making great work.

ACT TWO: ART COLONY IN DECLINE

But the Fine Arts Building has always been a privately held, commercial operation. The owners collect rent, and the widely varied tenants, unless they are independently wealthy, must focus on earning a profit from their labors. So instead of picturing the Fine Arts Building as a utopian enclave where dewy-eyed artists contemplate and create, remember that most of its occupants hustle to pay the bills.

In "Little O'Grady vs. the Grindstone," another novella from *Under the Skylights*, Fuller paints a sometimes hilarious portrait of Chicago artists in two buildings, the shabby Warren Block, or "Rabbit-Hutch" (presumably the Athenaeum), and the lofty Temple of Art (the Fine Arts Building) as they compete for commissions at the soon-to-be-built Grindstone National Bank:

> *By this time every 'art circle' in the city knew from its centre to its circumference that the Grindstone National Bank was moving toward the elaborate decoration of its new building and that the board of directors was thinking of devoting some twenty thousand dollars or more to this purpose. The Temple of Art took on its reception smile; the Rabbit-Hutch began a nervous rummaging for ideas among cobwebs and dusty portfolios and forgotten canvases; decorators of drawing-rooms and libraries put on their thinking-caps and stood up their little lightning-rods; and one of two of the professors at the Art Academy began to overhaul their mythology and to sketch out broad but hazy schemes for a succession of thumping big masterpieces, and to wonder whether the directors would call on them or whether they should be summoned to meet the directors.*

It was ever thus.

BELOW *Chicago Examiner* headline, March 30, 1915

BOTTOM The five Studebaker brothers

As post-pandemic commercial vacancies in the Loop prove, real estate is a precarious business, and even temples sometimes struggle to find tenants. Each time the Fine Arts Building changes hands offers a pointed reminder that it is indeed a for-profit enterprise whose continued existence depends on benevolent landlords. Just as artists need patrons, so, too, does an arts building. The building's tenants have been extremely fortunate to find one owner after another who believes in the mission—or at least tolerates it. Things could have gone south at any time.

The five Studebaker brothers were the first sympathetic owners, but by 1915, controlling stock in the Fine Arts Building Corporation had passed to thirty-one Studebaker heirs and Curtiss and the other stockholders were forced to dissolve the corporation. The property was sold to the family of the late Charles Chapin, a Chicago businessman, for $3,000,000, at that time the largest single real estate transaction in Chicago history. "The Fine Arts property has long been regarded as one of the most valuable in the Loop," observed the *Chicago Tribune*, but it would be ninety years before the building attained that cash value again—even without adjusting for inflation. The building would be sold again and again for less and less money as business partners squabbled, defaulted on tax bills, or simply tried to escape what they saw as a sinking ship.

Emily Chapin seems to have taken a special interest in the building. A philanthropist and gifted amateur artist, she took a suite on the tenth floor with her sons Homer, Henry, and Lowell, while allowing Curtiss to continue managing it as always from studio 528. But her time as caretaker was relatively brief—she died in 1925, and in 1937, her heirs filed for bankruptcy.

Ownership remains murky until 1945, when wealthy lawyer Abraham Teitelbaum (who described his former client Al Capone as "one of the most honorable men I ever knew") partnered with Paul R. Simon, another lawyer, to buy the building for $750,000 after the Bureau of Internal Revenue filed liens for delinquent tax and agreed to become a party to the sale. In 1952, Teitelbaum himself had to put his share of the building and both annexes on

ACT TWO: ART COLONY IN DECLINE

BELOW Chicago Youth Symphony Orchestra bass players, 1948

OPPOSITE PAGE Michigan Avenue and the Fine Arts Building, 1945

the auction block to make good on a delinquent income tax claim. His interest was purchased by paint manufacturer and realtor Arnold A. Schwartz.

In 1960, Simon's widow, Bessie, brought a court action to force the sale of the building. Superior Court Judge Grover Niemeyer ordered its sale, with the proceeds divided between her and Arnold A. Schwartz. Schwartz, who had owned half the building, now became sole owner with an offer of $925,105. When Schwartz died in early 1964, ownership passed to three heirs—his wife, Selina, her sister, Dora Rosenberg, and one still unknown—who appear to have been reluctant landlords.

The Fine Arts Building continued its slow decline, and as tenants moved away or died, the owners made little effort to replace them. Management

ABOVE Chicago Youth Symphony Orchestras students leaving the Music Room on the eighth floor, 1964

collected rent on the remaining studios while making only the most urgently needed repairs. In 1972, the *Tribune* published an item noting that the building had been offered for sale, valued at $894,623, "in a 'discreet' offering circulating only to qualified buyers." In keeping with the general attitude of unwantedness, the article's author suggested the land may have been more valuable than the building, adding, "That could mean potential buyers would be more interested in redeveloping the site than retaining the present building."

But even the attraction of a prime Michigan Avenue parcel wasn't attractive enough. No one bought it.

The sense of imminent danger to one of Chicago's cultural and architectural treasures did prompt the first efforts to preserve the Fine Arts Building. On August 11, 1975, it was added to the National Register of Historic Places—which, although it conferred no specific legal protections, was at least a start.

This, too, ushered in a period of hand-wringing about the building's future. From that time until the present, every few years local newspapers have sent reporters to wander the halls, soak up the atmosphere, and chronicle the building's condition. Wrote Paul Weingarten in the *Tribune*:

> *Many of the studios are dark now, but kids still flock there for lessons. Aspiring artists still paint in a few studios. The Chicago Symphony Orchestra practices there, and the Studebaker Theater attracts audiences, even though it can't compete with bigger theaters . . . And the building still offers much. You can buy a violin, have one repaired, or learn to play the instrument there; talk to a representative of the World Federalists' Association, or the Daughters of the American Revolution; worship at one of two churches; learn to sing, dance, design, or watch a scribe letter parchment.*

As those words were published in 1977, the Schwartz heirs were debating whether to accept Chicago Landmark status from the Chicago Landmark Commission, a designation that would protect the building from demolition or alterations that might compromise its character. Reportedly, two of the three heirs were inclined to decline—they wanted to sell to developers, even if the building would be torn down—but the third disagreed. If they remained deadlocked, the Chicago City Council would hold a public hearing, and with a recommendation from the Landmark Commission, make the final decision.

Chicago Tribune architecture critic Paul Gapp wrote, "Listening to the recent landmarks hearing on the Fine Arts Building was much like attending the wake of a distinguished old-timer who has made a lot of history and outlived most of his friends . . . the old masters are gone, and the culture is fading. One might almost say it carries the scent of death."

INTERLUDE

The Theaters

INTERLUDE

THE FATES OF THE THEATERS HAVE FOLLOWED THE FINE ARTS BUILDING'S FORTUNES—OR IS IT THE OTHER WAY AROUND? Studebaker Hall opened on September 29, 1898, to rave reviews. The larger of two ground-floor theaters, it seated fifteen hundred concertgoers on three levels with thirty-four box seats—a level of crowding the city of Chicago would rethink after the Iroquois Theater fire killed more than six hundred people just five years later.

INTERLUDE: THE THEATERS

LEFT Sarah Bernhardt in *Jeanne d'Arc* (1900) and *Phedre* (1874)

BELOW Accordion-style playbill for *The College Widow*, a comedy written by George Ade, 1906

OPPOSITE PAGE Studebaker Theater, 1898

Designed as a music venue with excellent acoustics, the Studebaker's inaugural performance was a piano concert by Fannie Bloomfield-Zeisler. But when musical bookings failed to materialize in sufficient number, Charles Curtiss converted the concert hall into a theater. Boston's Castle Square Opera Company performed there for two years, but its offerings, too, failed to pack houses. When the Studebaker finally hit its stride, it was with lighter works for larger crowds: *King Dodo* and *The Prince of Pilsen* played for long runs, and the musical comedy *Peggy from Paris*, written by Fine Arts Building tenant George Ade (studio 839), helped establish Chicago's reputation as a source of original works.

But theatrical success is measured with a short ruler. In 1907, the Studebaker was leased to New York theatrical producers Connor & Dillingham, who refurbished it and booked their own slate of programs that earned diminishing box office returns. There were some notable exceptions: in 1910, the legendary Sarah Bernhardt played a two-week repertory engagement that showcased her signature roles in *Camille*, *Phedre*, and *Jeanne D'Arc*.

| 63 |

ABOVE Studebaker Theater
after renovation

By the advent of World War I, the theater was in need of a rethink. Frohman, Klaw, and Erlanger operated it as a vaudeville house for several months, but couldn't compete with the three other theaters they operated locally. Their lowbrow fare also horrified the high-minded Curtiss—probably another reason the experiment was short-lived.

The Studebaker's first flirtation with film came in October 1915, when new management reopened it as a movie theater showing three movies for two dollars. One bill offered a Mack Sennett comedy, a Thomas Ince drama, and a D. W. Griffith spectacular. But when even this surefire scheme failed to catch fire, the building's owners and the theater's leaseholders decided to once again launch the Studebaker as a legitimate theater, this time under the direction of the Shubert Organization.

Notable Chicago architect Andrew N. Rebori designed and oversaw the major remodeling at a cost of $100,000. When it reopened in November 1917, the theater had been completely transformed. The side walls had been rebuilt, and the main floor, balcony, and gallery were all new. The stage had been reconstructed, the acoustics tweaked, the lighting reinstalled. Even the proscenium arch had been squared—all that was left of the original theater was its ceiling.

The theater appears to have been moderately successful in the following years, attractive enough that in 1927, utilities magnate Samuel Insull would take a five-year lease to showcase the talents of his wife. (See "Interlude: Chicago's Citizen Kane.")

Post-Insull, the Studebaker was leased to multivarious troupes of occupants,

including the Central Church (which held services there from 1944–1950) and NBC Studios (1950–1955). Bernard Sahlins founded the Studebaker Theater Company in 1956, hoping to install a permanent repertory theater company there that would perform both classics and contemporaries featuring Chicago talent. But Geraldine Page in *The Immoralist* and Harvey Korman in *Waiting for Godot* didn't help the company catch fire, and it ceased activities in 1957.

Sahlins, however, would shortly co-found the Second City—so maybe it's all for the best.

From 1957 on, the Studebaker was operated by multiple bookers and producers, including the Nederlanders, who brought stars to its stage in touring productions: Eartha Kitt in *The Owl and the Pussycat*, Martin Sheen in *The Subject Was Roses*, Henry Fonda in *Time of Your Life*, Peter O'Toole in *Present Laughter*, Rex Harrison and Claudette Colbert in *The Kingfisher*.

But on more and more nights the house was dark. Its final live production before its next rebirth may have been a traveling performance of *A Prairie Home Companion* in 1982.

BELOW Chicago Teachers Federation meeting, 1920s

BOTTOM Ticket envelopes, 1920s

University Hall, the second ground-floor theater, opened on December 29, 1899, and as a versatile, mid-sized venue, was in immediate demand. According to Duis in *Chicago History*:

> *During its first year, that 750-seat hall saw a highly diversified collection of gatherings. The University of Chicago held Extension classes and Convocation there. Ethnic singing and dramatics societies, innumerable charity benefits, the Order of the Eastern Star, and an Isadora Duncan dance recital kept the booking agent busy that first year. A few small religious groups with offices in the Fine Arts also used the hall, as did the followers of self-proclaimed agnostic Robert Ingersoll.*

Despite a name change to Music Hall around 1903, when a balcony was added, the space continued hosting a variety of concerts, plays, and meetings. Only five years later it was lightly remodeled and again renamed, this time the Fine Arts Theater, as management leaned into theatrical productions. Then in 1912, the venue was completely rebuilt as its new identity became more established. Starting in 1914, when no play was running, it became a part-time movie theater programmed by the delightfully named Alfred Hamburger Organization. Still more renovations took place in 1916 as the space was renamed the Playhouse Theater, a moniker that almost stuck. Despite being leased to Metro Pictures in 1919, the Playhouse continued to alternate between films and plays throughout the 1920s.

ABOVE Ads in *Chicago Daily Tribune*, 1899 and 1908; Music Hall, c. 1903

OPPOSITE PAGE World Playhouse marquee, c. 1972

The Playhouse's most interesting chapter began in 1927, when a few film-loving entrepreneurs founded the Little Cinema there in reaction to the so-called "popcorn palaces" popping up elsewhere in Chicago. With the newly created Chicago Film Guild as its advisory board—members included Edith Rockefeller McCormick and then–film reviewer Carl Sandburg in addition to usual suspects Lorado Taft, Harriet Monroe, and Jane Addams—the Little Cinema set itself apart both by its programming and by its style. The first film in its largely foreign and very serious slate was Sergei Eisenstein's *Battleship Potemkin*. The Little Cinema eschewed then-common music or skits between screenings, and usherettes wore mufti instead of the quasi-military uniforms found in most theaters. Patrons were encouraged to smoke the free cigarettes and even put their feet up on seat backs if they wished. One newspaper was so outraged by these developments that it called the Little Cinema "the I-Hate-Movies Club."

In 1933, with the Chicago World's Fair thrilling visitors from around the globe, the Playhouse Theater became the World Playhouse, Chicago's first art-house cinema. But under a series of indifferent owners and without significant new investment, it became shabbier and shabbier—finally showing X-rated films—before closing in 1972.

After the Playhouse briefly reopened in 1980 as a venue for chamber music—another false start—in 1982 both it and the Studebaker were taken over by

INTERLUDE: THE THEATERS

the Skokie, Illinois–based M&R Amusement Company. M&R converted them into dedicated movie theaters, the first to open in the Loop in a decade. Over the next two years, the spaces were chopped up to add two more screens, creating an oddly arranged four-screen multiplex. But it worked. Perhaps channeling the spirits of the Little Cinema's founders, booker Tom Brueggemann made the Fine Arts Theater *the* place to see first-run foreign, art, and indie films. Throughout the 1980s, it was where many Chicagoans had their first encounters with such films as *Paris, Texas*, *Repo Man*, *Stop Making Sense*, and *Blue Velvet*.

But conglomeration foretold the end. M&R sold their theater business to Loews in 1988. Then Sony bought Loews and merged with Cineplex Odeon to become Loews Cineplex. In 1991, Loews opened the art-themed Piper's Alley in Old Town, creating their own competition, and the Fine Arts became a cog in a nationwide chain.

Throughout the nineties, the programming so lovingly curated by Brueggemann gave way to schlock as the Fine Arts became a dumping ground for films dragging down more prosperous locations. The theaters' faded elegance felt more and more like shabby neglect: seats were broken, films were poorly projected, and the air inside could feel downright swampy in summer.

With growing competition from not only Pipers Alley but Landmark's Century Centre Cinema and others, the theater was losing money. In 2000, Loews Cineplex pulled the plug. The four films playing before the screens went dark were *Billy Elliot*, *Dancer in the Dark*, the Val Kilmer bomb *Red Planet*, and a low-budget indie called *Cleopatra's Second Husband* that registered a weekend gross of $173.

"Our intention is to convert them back to stage theaters," building owner Tom Graham told the press. "That's our fondest hope."

But after the theaters closed, they would sit empty and decaying for the next decade and a half.

OPPOSITE PAGE, TOP NBC converted the Studebaker into one of the largest broadcast studios in the Midwest, c. 1950

OPPOSITE PAGE, BOTTOM c. 1956

LEFT Theatergoers, 1940

INTERLUDE: THE THEATERS

ABOVE The boys and girls of the Wide Awake Club outside the Studebaker Theater, 1915

OPPOSITE PAGE World Playhouse, 1953

RIGHT Ellen Van Volkenburg and Maurice Browne, c. 1918

BELOW Playbill and stills from The Chicago Little Theater production of *The Trojan Women*, 1915

Theatrical activities in the Fine Arts Building have never been limited to its marquee showplaces. In addition to one-off plays, often satirical, put on by members of the Little Room, Anna Morgan staged small but serious performances of Shaw and Ibsen in her acting studio.

Then came the Chicago Little Theater. Chicagoan Ellen Van Volkenburg and Englishman Maurice Browne had met on vacation in Italy, become engaged, and returned to Chicago in 1911 with the idea of starting their own theater company. She wanted to become an actress and he hoped to write plays. They also planned to share works by European playwrights not yet well known in the US—Shaw and Ibsen, yes, but also Strindberg, Synge, Wilde, Yeats, and

more—with their own creative interpretations. Browne's mission statement was lofty, aiming for nothing less than "the creation of a new plastic and rhythmic drama in America."

But while Browne became director of the fledgling company, and Van Volkenburg its principal actress, he was no Insull (and, thankfully, she was no Wallis). Renting the Studebaker was not in their budget, so instead they leased a fourth-floor storage space. It was long, narrow, and studded with pillars, but somehow they managed to squeeze a ninety-three-seat theater inside. Actors and audience alike entered through doors at the back of the stage, which was tiny, only fifteen feet wide and eighteen feet deep, with the ceiling less than twelve feet above. The wings on either side were almost nonexistent.

The theater's size inspired its name and forced its principals to be even more creative than they may have intended. Their staging was simple, striking, and adaptable, with sets that used movable screens and lighting (including dimmers, then a novelty) to achieve powerful effects. Programs were printed on rice paper to minimize the noise as patrons turned pages.

Chicago Little Theater made its debut on November 12, 1912, with one-acts by Wilfred Wilson Gibson and William Butler Yeats. The second performance was a series of short plays by Arthur Schnitzler, and the third was Gilbert Murray's translation of Euripides' *The Trojan Women*, which would become their signature play. The Little Theater even went on tour, sharing their style of performance as far as Boston, before ending the season in more debt than when they started.

Despite their always precarious financial situation, Browne and Van Volkenburg kept a busy schedule in the following years with both local and touring

productions. At the Fine Arts Building, they created a salon of sorts, where august speakers addressed their Tuesday discussion group. Some came from the arts (Harriet Monroe, Theodore Dreiser, Edgar Lee Masters, Robert Frost, John Barrymore) while others undoubtedly opined on events of the day (Clarence Darrow, Emma Goldman, Margaret Sanger).

When war broke out in Europe in 1914, Browne and Van Volkenburg took *The Trojan Women* on tour, billing it as "the world's greatest peace play"—a stance that would have repercussions a few years later.

In the five years following its founding, Chicago Little Theater made its mark by producing forty-four plays, both classical and modern works, including eighteen world premieres and seven American premieres. They triumphed over the limitations of their tiny stage with staging, set design, and lighting concepts that remain striking today. Not only was it the first art theater to tour, but Van Volkenburg was even a pioneer of American puppetry, staging puppet shows inspired by a trip to Germany.

(In an interesting side note, the first publicly recorded use of the word *puppeteer* occurred in a 1915 *Chicago Tribune* society column that referenced *The Deluded Dragon*, a marionette show at Chicago Little Theater. The word was likely taken from a program written by Van Volkenburg. Previously, those who operated puppets were called *showmen*, because they put on a show—but she reasoned that, if mules were driven by muleteers, puppets would be manipulated by puppeteers.)

As ever, artistic success is one thing and financial success is quite another. The Little Theater probably toured too often, and many Chicagoans had never quite taken to the high-toned atmosphere at its home performances. Browne found himself under pressure from Charles Curtiss over unpaid rent. Then, when the United States belatedly entered World War I, those who considered themselves patriots were reluctant to patronize such a notoriously pacifist theater. In 1917, Chicago Little Theater closed its doors.

ABOVE Seating in the Chicago Little Theater, c. 1914, and playbills

OPPOSITE PAGE Chicago Little Theater floor plan, c. 1912

But its influence lasted. Its name and notoriety played a key role in the growing Little Theater Movement, which spread to Boston, Seattle, and Detroit. These little theaters also helped buck the Theatrical Syndicate, an organization of theater owners, managers, and booking agents who controlled almost all of the commercial theaters in the country. It was probably even an influence on Chicago's Off-Loop and storefront theater scene that took root in the 1960s and 1970s.

Though Chicago Little Theater was not the first experimental theater in Chicago (Laura Dainty Pelham at Hull House may have been the movement's true founder), it was the best known. *Theater Arts,* writing of the company's sudden demise, memorialized it as "the most important chapter yet written in the history of the art theater movement in this country."

There's a little museum on the fifth floor of the Fine Arts Building where visitors can learn all about its theatrical history. And there's a rental space called the Little Studio on the seventh floor, too—just waiting for the next visionaries to arrive.

ACT

Shabby Grandeur

THREE

ACT THREE

SPOILER ALERT: THE FINE ARTS BUILDING WAS NOT SOLD TO A DEVELOPER AND DEMOLISHED. On June 7, 1978, it was designated a Chicago Historic Landmark. And the following year, it fell into the hands of its next benevolent owner.

Tom Graham was an unlikely patron of the arts. Then thirty-eight years old, he was a loan officer at the First National Bank of Chicago whose work sometimes involved financing architectural restorations. On the side, he was a budding developer who had bought and sold several Evanston buildings. At the bank one day, he was arranging a loan for Selina Schwartz and Dora Rosenberg, who mentioned that they were still looking to unload the Fine Arts Building. His next words came out of his mouth almost before he knew what he was saying: "I'll buy it."

Their eyes must have lit up.

Partnering with Horn Chen (a fascinating entrepreneur who founded the Central Hockey League, among other ventures) and a handful of limited partners, Graham became the face of a group that ponied up just over a million dollars to close the sale. Graham quit his job at the bank in order to devote himself full time to the Fine Arts Building.

When he moved into his office in studio 812, Graham found himself in a building with only forty percent of its studios leased, one working theater

ACT THREE: SHABBY GRANDEUR

(the Studebaker), one shuttered theater (the World Playhouse), and one major tenant (the Harrington Institute of Interior Design). He also inherited Marjorie Pekar, a slightly eccentric bookkeeper who became devoted to him; Tommy Durkin, a colorful elevator operator fiercely protective of the building; and a crew of building engineers longtime tenants referred to, not necessarily fondly, as the "Irish Mafia."

(The union kept sending him Irish engineers, which was fine enough until one of them started making a habit of hiding out in artists' studios while the tenants were away—even making himself at home in Graham's office at one point. After Graham was confronted by tenants angry about the intrusions, he took the fellow by the collar and dragged him out of the building. Of Irish descent himself, he called the union steward and furiously demanded, "Don't you ever send me another Irishman again!" The next guy was Italian.)

But Graham was in his element. He fell in love with the building and its tenants and frequently made floor-by-floor rounds, from the tenth to the first, visiting studios to make sure everybody was happy. Given the finely tuned temperaments of some of his clients, this was not always an easy task. Head engineer Frank O'Connor told him, after watching a particularly one-sided encounter, "You have the patience of a saint."

Graham's feelings for his tenants were reciprocated. He seems to have been liked by them, even loved, which aided his efforts to fill the empty studios. But despite a strong financial incentive to find renters by any means necessary, the new landlord didn't let just anybody in: he discouraged rock musicians and directed business types to the IBM building. He told a newspaper, "This building is for artists, and I want to keep it that way."

While Graham's plans for big improvements over his twenty-six-year tenure often fell short due to lack of funding, there is no question he breathed life into the

BELOW Tom Graham with one of his own paintings, 1995

RIGHT Tom and Mary Graham, 2005

OPPOSITE PAGE Venetian Court

building. Its dimmed light brightened, casting its shabby elegance in a new and flattering glow. The building bustled with new activity as tenants began to return.

Adding to the good vibes, in early 1990, Tom met painter Mary Muskus when he dropped into a tenth-floor studio to find out who was subletting from the troublesome tenant who had established his sainthood. After they married the following year, Mary Graham began to play an active role in many of the positive things happening at the building. For years, she worked out of studio 206, a stunning space overlooking Michigan Avenue (currently occupied by L. H. Selman, Ltd., purveyor of fine glass paperweights). Eventually, she would even be drafted into supporting Tom in management, entering Marj's meticulously handwritten bookkeeping into a computer.

Married to an artist tenant, Graham became perhaps an even better landlord, and with Mary's encouragement and help, he began to promote the artists and their work. Starting in 1992, they held annual art shows in Curtiss Hall, and in 1995 created the Artist's Cooperative Gallery on the fourth floor in the former Chicago Little Theater space, where tenants' work could be shown and sold. The rapidly filling building grew even more lively.

"We used to have great parties," Mary recalled wistfully. "One Christmas it snowed a lot. His staff shoveled the snow in the Venetian Court, put a tarp over it, and stuck champagne bottles in the snow around the fountain."

If the turn-of-the-century Fine Arts Building had been elegant and high-toned, emulating the sophistication of the East Coast and Europe, it now hit its stride in a more egalitarian Chicago mode, where artist tenants and building staff mingled convivially. The best-remembered party host was none other than elevator operator Tommy Durkin.

DURKIN HALL

In Recognition of Tommy Durkin, the Gate Keeper of the Fine Arts Building since 1950, the lobby you are now standing in has been dedicated as Durkin Hall.

Since arriving from County Mayo, Ireland, at age 16, Tommy's reliable smile and helping hand has earned him admiration, respect and love from the many who have been passengers in his Elevator #1 over the years.

Tommy's impact on the spirit of the Building has extended to his creation, the Notre Dame Room, which he furnished with memorabilia of the exploits of his beloved ND Football team. Located on the Corporate Level (one floor down), Tommy welcomes visitors and friends with a traditional hospitality, warmth and care.

God Bless you Tommy, and many thanks.

His family: the Tenants, Employees and Management of the Fine Arts Building
December 1998

After immigrating to Chicago at the age of sixteen from County Mayo, Ireland, Durkin soon found work as a teenage elevator operator at the Fine Arts Building, sending part of his modest paychecks to family back home. On the job since 1950, he had been a guardian of the building even during its years of neglect, screening visitors with a cheery smile and a gimlet eye. He was known to menace the city's elevator inspectors by stopping the car between floors and intoning, "Now, you're not going to give us any trouble."

Sometime during the 1980s, Graham gave Durkin tickets to a Notre Dame football game and Durkin was immediately smitten with the Fighting Irish despite having never followed the sport. He turned a corner of the basement (which he called the "Corporate Level") into the "Notre Dame Room" and filled it with pictures and memorabilia that included a football signed by alumnus Joe Montana. He was reputedly so fond of his shrine that he came in on days off just to dust and tidy his displays—or maybe it was simply so he could hang out with his work family.

Durkin hosted two annual parties. His St. Patrick's Day corned-beef-and-cabbage luncheon was exclusive, with invitations extended only to his favorite tenants, maybe twenty in the early days with the number growing as time went by. Durkin cooked corned beef and cabbage all night on a two-burner hot plate in the boiler room before serving it to his guests on Belleek china.

But the Christmas party was a blowout, with anyone and everyone welcome to attend—sometimes as many as two hundred tenants and guests. Durkin, the consummate host, spent days repainting and decorating the boiler room. During the party, he made the rounds, refilling the guests' wine glasses and directing them to the bathroom down the hall, which he called "the Illinois Room." When guests thanked him for throwing such a wonderful Christmas party, he answered: "This isn't a Christmas party, this is a Notre Dame party. We wouldn't go to all this trouble just for Christmas!" It was the event of the year at the Fine Arts Building—even the owner adjusted his travel plans in order to attend.

In 1998, tenants honored Durkin with a bronze plaque dedicating the lobby as Durkin Hall. He tried to retire in 2000, but allowed himself to be coaxed back part-time until quitting for good in 2010.

Tommy Durkin died in 2013, aged eighty-one, from complications related to ALS. Today, all that remains of the Notre Dame room are a handful of curled photos taped to the wall, a green-and-gold "Notre Dame" and shamrock painted on a sunless window, and a green-and-gold logo painted on the floor. And, of course, the memories of those who attended his parties.

As for Tom Graham, he held on to the building as long as he could, reluctantly accepting it was time to retire in 2005. An avid amateur painter, not quite as gifted as his wife, he spent the next two decades traveling and painting. He died February 20, 2024, mere months after the building he loved so much celebrated its 125th anniversary.

TRAGŒDIA

INTERLUDE

Death in the Afternoon

INTERLUDE

PEOPLE SAY THE FINE ARTS BUILDING IS HAUNTED. People say almost every old building is haunted, of course. But walk the empty halls on a cold winter morning, when the only accompaniment to your footfalls is the eerie rattling of the metal mail slots in the old oak doors, and you might think it's haunted, too.

(The reason they do that, explains chief engineer Marcin Krol, is that the pressure is equalizing between the heated studios and the unheated hallways as the building warms up—but either you believe him or you don't. He was unable to convince one tenant that the hammering in the old steam pipes was not a demon stomping around the basement.)

But truly terrible things have happened there over the years. A music student stabbed his teacher, then cut his own wrist with a razor blade. (Both survived.) A custodian was shot in the head by an unknown assailant in the basement locker room. A man shot his partner five times as he chased her down the fifth-floor hallway into a bathroom stall. (Mercifully, she lived, but still trapped in the cycle of abuse, she married him while he served time for her assault.) A building engineer cleaning skylights without a safety harness plunged to his death. A troubled young man seeking a quick death jumped into the stairwell from the tenth floor but died slowly.

It's worth noting that these are historical events and the current owner is committed to safety. Tragedies will have occurred in any building that

INTERLUDE: DEATH IN THE AFTERNOON

has survived so long. And it's difficult to imagine that anyone could have prevented the murder on the tenth floor.

Everett Clarke had been an actor during the golden age of radio, appearing on the seminal soap opera *Betty and Bob* in the 1930s, as the announcer for WGN's *Chicago Theater of the Air* in the 1940s, and as the lead in a locally produced version of the national hit crime drama *The Whistler* in the late 1940s. He also read *The World's Great Novels* on NBC and appeared in *The Space Adventures of Super Noodle* on CBS.

Maybe he had a face for radio. His career seemed to decline with the rising popularity of television in the 1950s. Changing direction, he became a much-loved acting teacher, working for decades out of a studio on the tenth floor of the Fine Arts Building. Until one night—Tuesday, September 9, 1980—he didn't come home.

At 7:30pm, Peter Orr, his concerned partner, called Ann Lang, a painter who had the studio next to Clarke's. His door was locked, so she summoned an elevator operator, who opened the door with his passkey, sweeping aside notes from students who wondered why he'd missed their lessons.

Clarke was lying face up in a pool of blood on a small practice stage in the corner of his studio. He had been stabbed three times in the chest and once in the neck, the final thrust severing his jugular vein. The murder weapon, a pair of scissors, was lying next to the body.

BELOW Accounts of an attack on Mrs. Ann Lilienthal, 1933

| 95 |

Lang called the police, who must have quickly ruled out robbery as a motive: the dead man still had a gold chain around his neck and $107 in his pockets. But as they interviewed other tenants, it didn't take long to reconstruct the crime.

A violin restorer who worked next door reported that he had shared an elevator with Clarke after lunch and saw him greet a regular student on the tenth floor—a man who often waited for his lesson on a bench outside the acting studio.

A little while later, Lang, at work in her studio on the other side, heard Clarke cry out, "No, Paul! God, no, Paul!" followed by thumping sounds, as though someone was throwing books. Accustomed to hearing dramatic scenes play out, she assumed it was just another acting lesson and continued painting.

INTERLUDE: DEATH IN THE AFTERNOON

The violin restorer was at his workbench, talking to a coworker, when they both saw the young man from the hallway. This time, however, he was outside their north-facing window, working his way eastward along the narrow ledge. They watched in amazement as the man continued to the fire escape and began making his descent.

"You don't see that every day," one of them said wryly. Neither of them knew they were watching a murderer escape.

Police inventoried the Pauls in the appointment book lying open on Clarke's desk and started tracking them down. They got a break when, at 1 a.m. the following morning, attorney Edward Mogul called the police, telling them he had seen news reports that Everett Clarke had been killed by someone

ABOVE DeWit escaped via the ledge outside this window

| 97 |

named Paul, and that his client, Paul DeWit, was both a student of Clarke's and had recently shown violent tendencies.

Interviewed in his eighth-floor apartment at 3520 North Lake Shore Drive on Wednesday afternoon, Paul DeWit told police he didn't know Everett Clarke. He would be happy to stand in a lineup, he said, only he had to go to a night class. Police staked out his lobby, but he didn't go anywhere. When he finally appeared at 8 a.m. Thursday morning, they arrested him.

According to the testimony of the detective who interrogated him, DeWit confessed immediately after he was informed of his rights, saying he had gone to the studio intent on killing Clarke because the teacher had told him he could no longer help with his career.

He brought the scissors from home.

The portrait of DeWit at age twenty-one is a sad one. According to the testimony of his father, Cornelius DeWit, Paul started using drugs in high school and had had multiple run-ins with the law. After graduating, he drifted between short-term jobs and support from his parents, apparently dreaming of a career in acting. He spent a fair amount of time working out in a gym where he met many of his friends. He was arrested for prostitution in April 1980 after an undercover policeman followed an escort ad to his apartment.

Over the past year, the usually pleasant and friendly young man had become withdrawn and moody, prone to blank stares and emotional outbursts. His appearance became disheveled. He tried to asphyxiate himself by running a car engine in his parents' garage, and when he was revived, told his father the Mafia had a contract on his life and his mother had tried to poison him with arsenic. DeWit called his roommate from California and said he'd tried to jump off a tall building but didn't have the nerve. He claimed to his parents he was working as a waiter and a model, so they visited the restaurant where he told them he worked. When nobody there had heard of Paul, they confronted him and he admitted he was actually a sex worker.

RIGHT *Chicago Tribune* article, September 12, 1980

Student held in actor killing

By Philip Wattley

AN UNEMPLOYED drama student described by friends as an aspiring actor was charged with murder Thursday in the stabbing death of oldtime radio actor and drama coach Everett Clarke.

Police arrested Paul DeWit, 21, in his high-rise apartment building at 3520 N. Lake Shore Dr. after finding his name in the dead man's appointment book.

Police said DeWit, who is 6 feet 3 inches tall and weighs 180 pounds, has no visible means of income and lives alone in an expensive apartment across North Lake Shore Drive from Belmont Harbor.

At the time of his arrest he was on probation on a prostitution charge. He has reportedly confessed to the killing but refused to tell police his motive.

DeWit was held in the Wentworth District lockup.

CLARKE, 68, WHO was the radio voice of "The Whistler" and narrator of the old "WGN Chicago Theater of the Air," was found slain Tuesday night in his 10th floor studio in the Fine Arts Building, 410 S. MichiganAv.

Cries of "No, Paul! No!" were heard coming from the studio several hours before the body was discovered, according to Lt. John Hensley, Wentworth Area homicide commander, who headed the investigation.

Hensley said an occupant of the building who heard the cries attached no significance to them at the time, thinking they might have been part of a drama lesson.

Clarke was found by a janitor at 8 p.m., fully clothed, lying on his back on a blood-spattered practice stage. A bloody pair of scissors lay nearby.

Dr. Robert Stein, Cook County medical

Continued on page 22, col. 1

Things came to a head in August and September as DeWit's persecution complex raged out of control. People were trying to kill him, he was sure: his parents, people at the gym, the Mafia, his roommate, mysterious snipers. He told a friend movie producers were following him, trying to force him to sign a contract against his will.

The day before the murder, the six-foot-three, 180-pound DeWit was arrested after he tried to break down a former lover's door with a sledgehammer. When his father came to bail him out, Paul said the man owed him $750,000 but the circumstances were too difficult to explain.

To his victim, he had said, "Nothing matters now. Next time, I'll be back with a gun."

He went to the Fine Arts Building instead.

At DeWit's trial one year later, his lawyers urged the jury to find their client not guilty by reason of insanity, and both the defense and the prosecution marshaled psychiatrists to their side. A neurological exam revealed no organic brain abnormalities in the defendant. A psychodiagnostic test indicated paranoid schizophrenia: DeWit had hallucinations and believed he could control events with his thoughts. Yet another test indicated he was exaggerating his responses in an attempt to appear sicker than he was.

Testifying for the defense, one expert witness declared DeWit insane, saying he was disturbed and delusional, unable to know what was or wasn't real. Another believed DeWit didn't know what he had done was wrong. The psychiatrist testifying for the state found DeWit's mental state to be "excellent" and described him as "in touch with reality."

Both sides had points. DeWit was clearly paranoid and delusional, but he had also brought a murder weapon intending to use it, mapped his escape route beforehand, and initially attempted to mislead police, a sign he knew he had broken the law.

After deliberating for six hours, the jury split the difference and found DeWit "guilty but mentally ill," the first use of a novel option in Illinois criminal law. Because he was mentally ill (and his judgment therefore impaired), but not insane (which would have rendered him "unable to conform his conduct to the requirements of law"), he was simultaneously guilty of murder and not guilty by reason of insanity.

DeWit, silent for most of the trial, began weeping as he was sentenced to twenty-two years' imprisonment. Under the new law, he would first be sent to a mental hospital until he was "cured," then serve the remaining time in prison. His parents were by then living in Brazil, where Cornelius DeWit worked for the Ford Motor Company.

Paul DeWit appealed in 1984. Richard M. Daley, State's Attorney, still five years from the office of mayor, represented the people of Chicago. The conviction was upheld.

Everett Clarke is buried in block seventy-three, lot three, grave number five at Zion Lutheran Cemetery in Oak Brook.

ACT

Renais-sance

FOUR

ACT FOUR

BOB BERGER HAD WANTED THE FINE ARTS BUILDING FOR A LONG TIME. And in the telling of Tom and Mary Graham, shortly after *Chicago* magazine published an article about it in August 2004, Berger was on their doorstep with an offer to buy. It's easy to see why the real-estate investor found it a good fit for his portfolio: he was a fan of art and artists, and his Berger Realty already owned the Flatiron Building in Wicker Park, whose artist studios made it kind of a Fine Arts Building in miniature.

As Berger courted the Grahams, telling them the building would "keep him young," another offer arrived. The nonprofit Fine Arts Building Foundation, led by Jan Kallish, former executive director of the Auditorium Theatre, had been working quietly on an ambitious plan to buy, restore, and transform the building and its theaters into an arts center with a strong educational component and close ties to local institutions. Representatives believed their offer was competitive, but their financing was more complicated, and Berger—who claimed to be unaware of the competing bid—paid cash. The sale closed in 2005 for a reported $10.4 million.

Mary hated to leave, but Tom had grown tired of the never-ending cash-flow problems and was ready to retire. Eighty-one-year-old Marj stayed on for three months to complete the bookkeeping, still working in pencil and hunched over her ledgers like Bob Cratchit in *A Christmas Carol*. When her work was finally done, "she went home and died," according to Mary. The building had been Marj's life.

ACT FOUR: RENAI//ANCE

(A tenant swore he saw her on the stairs a couple of months later—so maybe she returned as a ghost.)

Berger claimed he wouldn't change anything, as many new owners do, but naturally, he had his own ideas. He floated plans to stream performances online, to launch a recording label, maybe publish a coffee-table book about the building. Some tenants likely felt nervous about the new regime in light of a 2001 kerfuffle at the Flatiron when, perhaps inspired by MTV's *The Real World: Chicago*, Berger installed cameras in the hallways to live-stream tenant activity. Most of his big ideas for the Fine Arts Building did not come to pass, although, much to Mary Graham's chagrin, he did not support the fourth-floor Artist's Cooperative Gallery and it closed in 2006.

Berger's style was indisputably different from Graham's. Where Graham was laid back, Berger leaned forward, acting more like the owner he was and clashing with some of his tenants. But in other ways he suited the building perfectly. He carried a harmonica in his pocket, and at least once, surprised a Chicago Architecture Foundation tour group when he burst out of a studio honking a trumpet.

Like Graham, he truly loved the building, and it continued to teem with activity under his ownership. Even better, he began slowly bringing the Studebaker Theater back to life. Work began in 2014 to restore the theater, and Milad Mozari, then at the School of the Art Institute, 3D-printed the shapes necessary to restore its ornate but water-damaged ceiling. The Studebaker reopened on October 18, 2015, after modest renovations. Soon Chicago Opera Theater and the Chicago Jazz Orchestra, both Fine Arts Building tenants, were holding performances there. The Chicago Humanities Festival used the venue for events, including a talk by filmmaker John Waters. Momentum seemed to be building, and in 2019, the producers of *Wait, Wait . . . Don't Tell Me!*, NPR's hit news quiz, declared their interest in moving the show into the Studebaker.

Then came the annus horribilis.

LEFT Proscenium arch of the Studebaker

OPPOSITE PAGE Erica Berger, owner of the Fine Arts Building, with Jacob Harvey, artistic director

On March 21, 2020, with COVID-19 spreading around the globe, Chicago went into lockdown. Like everyone else in the city, tenants of the Fine Arts Building were forced to stay home for weeks. Except for two building engineers who came in daily to keep the building operational—navigating raised bridges and crossing police checkpoints during the summer riots—the halls fell silent for the first time in more than a century.

The artists began to trickle back, their studios both a creative outlet and an effective quarantine. But on November 6, tragedy struck again: popular building manager Blake Biggerstaff, a longtime employee of Berger Realty who had helped the Flatiron win the Chicago Landmarks Commission Preservation Excellence Award, died unexpectedly at the age of forty-four.

Erica Berger, Bob's daughter, stepped in to help the family business through the crisis. But with her new, closer perspective, she was surprised by the ad hoc nature of the operation: tickets to Studebaker shows were sold via PayPal, among other quirks. If the theater was going to succeed, it needed a comprehensive vision—and a full-time staff. Treating the aging business like a startup, she hired Jacob Harvey, formerly of Cirque du Soleil and Greenhouse Theater, as managing artistic director to create a theatrical strategy and hire a team that could professionally support visiting productions. One of his first moves was to bring in Alexander Attea, an accomplished playwright, as marketing manager.

The transformation had barely begun when, on June 19, 2021, Bob Berger died at the age of eighty-six. And Erica Berger found herself the owner of the Fine Arts Building.

Recent events notwithstanding, her path had been leading her away from the family's real estate business: after studying international relations and business at UCLA, she leveraged a strong background in environmental issues and environmental policy in her work as a journalist, media executive, and documentary filmmaker. She made and exhibited art, too, became a KRI-certified kundalini yoga teacher, and even performed comedy. She no longer lived in Chicago full-time.

Yet the fifth-generation Chicagoan had grown up in a household where supporting the arts was important. She took seriously the stewardship of the older buildings in her father's portfolio. And she remembered the excitement in his voice when he called her at college to tell her he'd bought the Fine Arts Building. She had visited it many times and knew how much he loved it. Seeing the place as both Bob's and Blake's legacy, she dropped everything and rolled up her sleeves.

In August 2021, Berger announced a major renovation and restoration of the Studebaker. Working with architect Brian Hammersley, a Fine Arts Building tenant (studio 941), as well as theater specialists Schuler Shook and Threshold Acoustics, Berger and Harvey forged ahead with a comprehensive overhaul. The Studebaker Theater reopened in May 2022 with a rebuilt stage, new seats, and state-of-the-art sound and lighting, then briefly went dark again in early 2023 for the installation of automated rigging, new curtains, and the final touches on the A/V and lighting

STUDEBAKER·THEATRE

MaNuaL CiNeMa's
FRaNKeNSteIN

OCTOBER 25 – 27, 2024
STUDEBAKER THEATER | FINE ARTS BUILDING

"ENDLESSLY IMAGINATIVE...
EXQUISITELY BEAUTIFUL."
THE NEW YORKER

"...AN EXQUISITELY STYLIZED,
SELF-CONTAINED REALITY."
THE NEW YORK TIMES

"A MAJESTIC ACCOMPLISHMENT
THAT BOGGLES THE MIND."
CHICAGO THEATRE REVIEW

"...IMPOSSIBLE TO
LOOK AWAY."
DAILY BEAST

312.753.3210
FINEARTSBUILDING.COM

systems. Berger said she invested "many, many millions of dollars" refurbishing both the theater and the building.

The first show to take the rebuilt stage, *Skates: A New Musical*, was a flop. It probably didn't help that, in a musical about a roller-skating, there was no actual roller-skating. The next show, *Personality: The Lloyd Price Musical* debuted in the summer of 2023 and played to better reviews and some half-full houses. Bit by bit, the shows kept coming, from *Emmett Otter's Jug-Band Christmas*, with puppets created by Jim Henson's Creature Shop, and "Dog Man: The Musical," to a Paula Poundstone comedy show, author Percival Everett, and—hearkening back to the years when the Fine Arts Theater showed movies—fortieth anniversary screenings of the Talking Heads concert film *Stop Making Sense*. All this in addition to live recordings of WBEZ radio programs *Mortified* and *Science Friday*, and the ongoing residency of *Wait, Wait . . . Don't Tell Me!*

The theater seems to be the right size for trying new things: debut musicals (*Bronzeville the Musical*), a new talk show (*Late Nights in Chicago*), even *Magic Men Australia*, a male dance revue billed as an "epic girls' night out."

The fall 2024 season was the busiest in a long while. The October calendar alone featured the North American premiere of *Leonora* by Chicago Opera Theater; *Absent Moon*, a dance recital by Winifred Haun and Dancers; a Brahms violin concerto presented by Camerata Chicago; a screening of the cult silent film *Aelita: Queen of Mars*, with music by Marc Ribot; and Manual Cinema's one-of-a-kind interpretation of *Frankenstein*.

The theater is coming back to life.

ACT FOUR: RENAI**SS**ANCE

There is still work to be done at the Fine Arts Building. Carriage Hall, the smaller of the two first-floor theaters, remains dark, awaiting its next incarnation. The windows on the street-level retail spaces have brand-new black-iron framing and gleaming window glass, but the shops behind them remain empty. The restaurant needs a new tenant to represent the culinary arts. Yet in every other way the building is thriving. The building is over ninety-five-percent leased with an active waiting list. Second Fridays, a monthly evening event in which artists open their studios to the general public, have never been more popular, bringing in a steady stream of first-timers who wander the hallways with mouths agape. The smaller galleries and performance spaces bring in artists and patrons at all hours. There's always something happening.

Erica Berger may be an accidental owner, but she may also be the most passionate owner yet, with a powerful vision for what she wants to achieve.

"This is first and foremost about creating a great place for art to happen, but also to ensure the Fine Arts Building maintains its place in the cultural fabric of Chicago," she said. "With our Studebaker Theater, we're trying to become a place where people from different backgrounds, from all over Chicago, can come to tell their stories. And that's very deliberate. That's not the most profitable thing to be doing, but our city needs some serious healing. And it needs buildings like Fine Arts that have been historically these points of reference for community and engagement and magic."

Magic—that's the word. Because this particular form of time travel is available to everyone. All you have to do is walk in off Michigan Avenue, under the building's motto, and into one of the beautiful old elevators. Where you take it—the past, the present, or the future—is up to you.

ABOVE George Mitchell's Artist's Café, 1993

FOLLOWING SPREAD Elevator operator Waclaw Kalata

INTERLUDE

A Thrilling Ride

INTERLUDE

PRESS THE DOORBELL-STYLE BUTTON TO CALL AN ELEVATOR AT THE FINE ARTS BUILDING, AND AFTER A PLEASINGLY MECHANICAL *BRRING!* YOU'LL HEAR A SOFT RATTLE OF CHAINS AS THE CAR DESCENDS FROM ABOVE. Looped cables appear through the glass panes in the door before the car slides into view with its occupants startlingly visible.

Step inside, and the operator closes the heavy outer door with a crisp BANG, then lowers the rod that locks it in place. The elevator men (they are all men) navigate not by pressing buttons but by operating an almost nautical brass throttle with a wooden handle, pushing forward to climb, pulling back to fall. Most don't close the latticed safety gate unless the car is crowded or the passengers are tourists. Tenants and regulars are allowed to hold themselves back as the car rises and the floors fall away below.

If modern elevators offer sterile teleportation, this offers the thrill of a carnival ride. And no wonder: in 1914, the cable suspending an overcrowded car snapped on the fourth floor, dropping sixteen passengers in terrifying free fall. The emergency brakes stopped the car mere feet from the bottom of the shaft, but even then, the danger was not over. The severed cable lashed

INTERLUDE: A THRILLING RIDE

into the car like an angry snake, further injuring several of the passengers. Mercifully, no one died.

Stopping the cars is more art than science. The longest-serving operators have a knack for getting it right on the first try, but even veterans frequently miss floor level and must jockey back and forth until the car is aligned. Newbies and fill-ins sometimes miss the mark by several feet or more.

Each car handles differently, its quirks only apparent after time and practice. Number One, currently undergoing an update (more on that in a moment), was the fastest and had the most sensitive brake. Number Two is larger and less responsive, gliding to a stop. Number Three, originally intended for use by building engineers, is even slower. Number Four has been decommissioned for years, its shaft reappropriated for electrical conduit, internet cabling, and sprinkler pipes.

There is no system telling the operators from which floor a rider is calling. Once upon a time, an elegantly contrived brass mechanism on the roof triggered lights that indicated whether cars were going up or down, while also alerting operators via a gauge in the car where passengers were waiting. Now, when the bell echoes down the shaft, the elevator men must conduct a visual search, scanning floors as they go with the assistance of thin rectangular mirrors mounted on the side of each car's doorway. Operators are often halfway past the floor before they spot the caller and hang briefly in the air before backing up.

BELOW *Chicago Daily Tribune* headline, April 28, 1914
BOTTOM LEFT Elevator throttle
BOTTOM RIGHT Side-view mirror
OPPOSITE PAGE Elevator operator Brian Feeley

OVERCROWD LIFT; CABLE BREAKS

Safety Clutches Prevent Probably Fatal Elevator Accident in Fine Arts Building.

CAR DROPS FOUR FLOORS.

Several of Sixteen Persons Who Were Jammed Into Cage Badly Shaken Up and Bruised.

INTERLUDE: A THRILLING RIDE

ABOVE Chief engineer Marcin Krol and elevator machinery

The operators, who belong to the International Union of Operating Engineers, Local 399, all follow in the footsteps of the legendary Tommy Durkin, for whom the first-floor hall is named. Waclaw Kalata, the longest-serving operator with more than thirty years of service, was trained by Durkin himself. For years, Kalata's cousin, Waclaw Gutt ("the other Waclaw" in building parlance) worked the night shift. Both men had been guided to their jobs by a countryman from their village of Szaflary, near Zakopane in southern Poland. Robert Kurdej, another Polish immigrant, found his way to the Fine Arts Building after working as a maintenance supervisor at two other classic Chicago buildings, the Rookery and the Merchandise Mart.

Brian Feeley got his job "the old Chicago way: I knew somebody who knew somebody." Perhaps because of his familiar accent, the only Chicago native on the elevator crew has been a public face of the building repeatedly, interviewed twice on local TV and given a cameo in *Chicago Fire* (where he both operated the elevator and appeared on camera as a trapped passenger).

Although Nevada Bradley, Jr. was initially brought in to do maintenance, he was soon operating elevators, and indeed his duties seem to include a little bit of everything. He has been at the Fine Arts Building only five years but could mount a credible campaign to be its mayor. Of all the elevator men, he

ABOVE Elevator operator Nevada Bradley, Jr.

OPPOSITE PAGE Elevator Certificate of Inspection (1969) and metal plaque once displayed inside the elevators (c. early 1900s)

is most likely to offer a greeting, joke, observation, or opinion. He goes out of his way to direct visitors to points of interest and will genially scold them for ringing the bell twice.

The four full-time operators are supplemented by a rotating cast of part-timers with varying levels of experience.

Like anyone whose work requires skill and has consequences, all of the elevator men have stories of mishaps, nothing serious, told with wry and self-deprecating humor: overloaded elevators that stopped in mid-flight, climbing out between floors, hard landings. But it's a testament to the resilience of both the equipment and the operators that nothing serious has happened in living memory.

Chicago's last publicly accessible, manually operated elevators have been living on borrowed time for years. Sensing this, local media editors have commissioned obituaries and eulogies for the past two decades. Now the end is finally approaching.

On August 24, 2023, Berger Realty finally made it official, citing both the cost and challenges of maintaining the antique equipment as they announced "the difficult decision to convert our manual elevators to updated mechanical

INTERLUDE: A THRILLING RIDE

INTERLUDE: A THRILLING RIDE

ABOVE Elevator operator Brian Feeley

elevators." The code-compliant modern elevators will maintain the historic appearance of the originals as much as possible—but the cars will be self-driving.

The schedule called for the whole job to be completed before this book's publication, but Number One was still months behind at press time. Renovations of historically significant buildings are notoriously complicated. So who knows when it will be done?

The elevator operators have been offered the choice of severance pay or continued employment in other capacities. Kalata will probably bow out when the elevators do. Bradley plans to stick around. Others are still mulling their options, waiting to see how long the project will actually take.

Visit the Fine Arts Building and ride the elevators while you can. Say hello to the elevator men. And thank them for a memorable ride.

ACT

The Artists Endure

FIVE

ACT FIVE

THE FINE ARTS BUILDING'S MANAGEMENT TEAM ISN'T SURE EXACTLY HOW MANY STUDIOS THERE ARE, ESTIMATING THE NUMBER BETWEEN 175 AND 190. The artist spaces in the 200,000-square-foot building have been modified so many times—combined or cut up as tenants' needs grew or contracted—that even the engineers don't know which partition walls are original.

Counting the artists working within these walls, or surveying their artistic disciplines, might be equally futile: some of them share space, others are employed by the leaseholders, many simply come to the building for lessons or collaboration. Some are multihyphenates: Cecilia Beaven (studio 915), for example, paints, draws, animates, makes movies, and sculpts. And of course, tenants move in and out almost every month.

The most up-to-date listing of tenants can be found on the building's website directory. The most pleasurable way to discover them, however, is to wander the halls. Studios whose historic tenants were notable are marked by placards with capsule biographies, but current tenants choose how much or how little they want to share. Many offer brochures, postcards, and business cards, or post articles about themselves or their work—Kundalini Yoga in the Loop, studio 514, has an extensive display—but others carry on in secret, with no identification beyond the numbers on their doors.

A few are playfully misleading. The frosted-glass window of studio 420 advertises "The Law Offices of Sterling Bodett and Bodett, specializing in aesthetic litigation

BY APPOINTMENT ONLY" but is actually the studio of visual artist Matt Bodett, who is not a lawyer but a teacher at Loyola University and Columbia College. He also curates the next-door gallery, Press Here: Center for Mad Culture, "which explores the cultural and aesthetic possibilities of madness." Then there is the narrow, unnumbered door next to the seventh-floor restroom, labeled Chicago Designer Closets. You might think someone's having fun—but that's real.

(This playfulness has precedent. When Tom Graham owned the building, an unknown tenant carefully lettered a sign identifying an unleased studio as the William Shatner School of Acting. Then again, the United Planetary Federation, also in the building, was real—as far as that goes.)

What is known is that the sheer variety of tenants is astonishing. In the Fine Arts Building you can find architects, art therapists, authors, a barber, a bookstore, a ceramicist, chamber musicians, a collagist, a commercial realtor, counselors and therapists, dance instructors, a literary editor, filmmakers, a financial advisor, a flute repairer, a fundraising and grant-writing consultancy, a guitar teacher, illustrators, interior designers, a jewelry maker, lawyers, mediators, a mouthpiece maker, opera singers, painters, a paperweight dealer, photographers, pianists, puppeteers, a talent agency, a sheet music store, singers, violin shops, vocal instructors, a woodwind maker, and yoga instructors.

Singers, actors, and musicians can find almost everything they need for their careers: agency representation, auditions, haircuts, head shots, coaching and training, sheet music, fundraising expertise, rehearsal space, yoga for mindfulness, massage after a performance, therapy, counseling, and even legal representation should things go awry.

They can even find affordable space in which to practice—or start a new practice of their own.

ACT FIVE: THE ARTISTS ENDURE

STUDIO 560

WILLIAM HARRIS LEE AND COMPANY

CHICAGO NATIVE BILL LEE FELL INTO VIOLIN-MAKING DURING HIGH SCHOOL, WORKING FOR A FAMILY FRIEND. After a brief stint in New York, he returned to Chicago to start his own business, choosing the Fine Arts Building because of its proximity both to the Kenneth Warren School of Violin Making at State and Wabash (now the Chicago School of Violin Making in Skokie) and Bein and Fushi (studio 1014), a premier authenticator, restorer, and dealer of fine violins.

Lee started in a small space on the tenth floor. He wasn't making violins yet but importing, distributing, and supplying dealers with instruments and supplies. Bein and Fushi became both his customer and his part-time employer: in the evenings, he performed repairs and further developed his craft under the watchful eye of Bill Webster.

William Harris Lee and Company grew rapidly, expanding to fill all the studios on the west side of the tenth floor, but soon needed even more space. According to Lee, when Tom Graham bought the building, Lee asked whether the annex was available, so Graham walked him to the Michigan Avenue annex.

"No, the other annex," Lee corrected him.

"What are you talking about?" asked Graham.

"There's this doorway on the fourth floor and you go across this bridge over the alley to the other building on Wabash."

"He came back a little while later," remembered Lee with a chuckle. "And said, 'Well, I didn't even know we had that.'"

They took space in the Wabash annex on the top floor, sharing the six-story building with the Chicago School of Professional Psychiatry, a naprapathy clinic, the offices of *Streetwise*, and a daycare center. Still growing, they ultimately took over almost the whole building. His son, Eli Biagi-Lee, recalled that when the weather was cold, the freight elevator had to be taken up and down several times for the running start necessary to reach the top of the building.

Shortly after Bob Berger became the owner in 2005, Lee and Company did move into the Michigan annex, taking their present space (studio 560) on a

ACT FIVE: THE ARTISTS ENDURE

floor that had been used by the Harrington School of Design but was now in rough shape. During demolition, they found the original stained glass and arched doors that Frank Lloyd Wright had designed for the Thurber Art Galleries a century before.

Around 1980, Lee's shop had begun making its own violins with makers Will Whedbee, Gary Garavaglia, and Tetsuo Matsuda. Of the "O.G. Three," as Biagi-Lee affectionately calls them, only one remains with the firm: Whedbee builds cellos out of his own North Side shop; Matsuda passed away in 2023; but the genial Garavaglia, now in his late seventies, still walks to work every day.

Supported by Biagi-Lee, who handles PR and operations, Lee has built a violin empire that anchors the Fine Arts Building's status as a center for violin making, repair, restoration, and sales. In the Fine Arts Building, they occupy most of the fifth floor, where they recently added a second showroom, as well as a varnishing room on the roof. This is their hub for instrument making—not just violins but violas and cellos, too—with warrens of workshops, a retail shop, two reception rooms, storage rooms, and a hidden loft for lumber. A shop in Wilmette is focused on restoration, and one in Atlanta primarily handles sales and rentals. Employing 30 or so people, Lee claims his company is the largest violin-maker in the United States, building 15 to 20 instruments monthly, each of which requires roughly 150 maker hours—carving, gluing, varnishing—to complete.

ACT FIVE: THE ARTISTS ENDURE

| 129 |

> " STRADIVARI'S WORKSHOP, AMATI'S WORKSHOP, THE GREATEST WORKSHOPS, HAD MANY PEOPLE WORKING IN THEM. BUT THAT'S NOT THE IMAGE THE YOUNGER GENERATION IS THINKING ABOUT. THEY KIND OF WANT TO BE GEPPETTO. "

And with a few notable exceptions, says Lee, the greatest shops in history operated at scale, too. That's an image at odds with the romantic notions of many aspiring luthiers.

"They actually have the idea that, 'Oh, I have to make everything myself, the way the old masters did,' without any concept of the fact that Stradivari's workshop, Amati's workshop, the greatest workshops, had many people working in them," said Lee with a chuckle. "But that's not the image the younger generation is thinking about. They kind of want to be Geppetto."

Added Biagi-Lee, "A lot of people have this idea that those makers we look up to still, that they would be doing it all by hand. They might not be 3D-printing a violin—but they'd be using the machines that refined and improved their process."

The studios of William Harris Lee and Company are rambling, encompassing everything from a reception room with a stunning view of Grant Park to well-used workshops where sawdust and curls of wood are swept away at the end of each day. Walls are hung with violins and violas and floors are stacked with instrument cases. Despite the size of the operation and the buzz of activity, it retains the feel of a family business and very much carries the personality of its genial founder, who loves to tell stories about the building.

ACT FIVE: THE ARTISTS ENDURE

STUDIO 915

CECILIA BEAVEN

CECILIA BEAVEN FIRST DISCOVERED THE FINE ARTS BUILDING BECAUSE SHE WAS HUNGRY. The visual artist and native of Mexico City was visiting the School of the Art Institute of Chicago (SAIC) as a prospective student when she stopped at the Artist's Café for lunch. Her first impression when she stepped inside the building?

"I thought it was insane," she recalled. "Just so old and beautiful, like from a movie or something."

Although drawn to SAIC because of its big-city campus, and to Chicago because of comics artists such as Chris Ware and Daniel Clowes, she never planned to stay. But after earning her MFA in 2019, she joined the SAIC faculty and now teaches painting, drawing, and comics making, commuting by bicycle from her home in the South Loop.

> **"WITH MY WORK, I'M TRYING TO AFFIRM THAT AGENCY THAT I HAVE AS A CREATOR. TO PLAY WITH CULTURE AND PLAY WITH VISUAL ASPECTS OF WHAT BEING MEXICAN MEANS AND REINVENT THEM."**

Her work takes an extensive range of forms, from drawings and paintings and murals to animation and sculpture. Some are large, some are small; some are studio pieces, some are public installations. Much of her work, which she describes as "playful and bold, cartoony in some ways," incorporates elements of Aztec mythology.

"My idea is to rethink it and reevaluate it in our time, and question who gets to tell stories, who gets to define how our culture looks or what it is," Beaven explained, adding that she finds the folkloric aspects resonate with audiences outside the fine art world. "I'm very interested in how history and mythology—all these things that we take for granted because they seem so institutional—they're fictions, and they were created by people.

"With my work, I'm trying to affirm that agency that I have as a creator. To play with culture and play with visual aspects of what being Mexican means and reinvent them. I also use myself as a character in my work a lot, which follows a logic that comes from comics, like designing a character."

Beaven recently marked her two-year anniversary in studio 915, making her one of the building's newest tenants. She especially enjoys hearing the luthiers at McLaughlin Violins (suite 908) testing their violins and bows. And she's delighted by the building's puppeteers. Above all, she loves her studio.

"My studio faces the lake, so there's always natural light, which is very important for my work. I have spent several all-night working sessions there, and then I get to see the sunrise and it's really amazing."

ACT FIVE: THE ARTISTS ENDURE

| 135 |

ACT FIVE: THE ARTISTS ENDURE

STUDIO 1020

JOHN K. BECKER AND COMPANY

THE STUDIO OF JOHN K. BECKER AND COMPANY IS ELEGANT AND AUSTERE. From the carefully restored reception room to the exactingly organized workshops, this suite of rooms under the tenth-floor skylights has an almost monastic atmosphere. The work here is intent and hushed, a reflection of the soft-spoken founder himself. If Bill Lee on the fifth floor is an entrepreneur, Becker remains a maker, a man wholly devoted to his craft.

Becker was one of many young people in the 1970s who found themselves caught up in the revival of interest in woodworking and other handicrafts. After building an electric guitar in high school (which he gave to Randy California, the lead singer of his favorite band, Spirit), he apprenticed as a harp maker at Lyon & Healy. He liked the work but was frustrated by the fact that harps are finished by several different departments.

> **" I REALLY ENJOY BEING IN THE BUILDING. IF YOU WORK ON 400-YEAR-OLD INSTRUMENTS, YOU LIKE OLD THINGS. "**

"I was more geared to working on smaller things," he recalled.

Wanting to try violins, he applied to Bein and Fushi, and was accepted as an apprentice in 1979. Their program was notoriously competitive—Becker estimates the attrition rate at nine in ten—but he excelled at the work: "I turned out to be one of the best applicants they ever had, according to Robert Bein."

He became their lead restorer after only three years, in 1982, then took charge of the whole workshop in 1989, playing an integral part as they rose to become one of the world's most highly regarded shops for repair and restoration of the world's finest violins. Seeking more control over decision-making and supply chain, with Bein and Fushi's blessing he went into business for himself in 1994. He kept the same studio and still did some work for his former employers as their sales functions became more separated from his workshop. Key clients, including Joshua Bell and James Ehnes, followed the man ranked by some as the finest craftsman in his field.

His footprint in the building has grown from his original two studios, 1020 and 1019–1020 (Frank Lloyd Wright briefly occupied 1020, from 1910–11) to encompass seven spaces in all. Despite the challenges of operating in a historic building—leaks, heat, and humidity—Becker remains sanguine.

"I really enjoy being in the building," he said. "If you work on 400-year-old instruments, you like old things."

ACT FIVE: THE ARTISTS ENDURE

It remains a small shop focused on excellence, and like W. H. Lee, is a family business. Becker works with his sons Garrett, who builds Stradivarius-style violins using traditional techniques, and John J., who handles the business end and is a musician in his own right. Their father is still happiest at his bench, working quietly alongside master restorer Keisuke Hori and luthier Takeshi Nogawa.

An interesting fact is that neither Bill Lee nor John K. Becker plays the violin. Becker says many repairers and restorers play a little, but he doesn't know any who are exceptional players. After all, it takes as much time and effort to master playing as it does making. Their job is to adjust violins for the preferences of their intended players, not themselves.

In that way, their most important attribute may be their ears. Other violin shops in the Fine Arts Building include Carl Becker and Son (studio 460), Guadagnini Violin Shop (studio 719), and McLaughlin Violins (studio 908). Music Row is long gone, but proximity to Orchestra Hall still means something, as does easy access to the Blue Line and O'Hare. Musicians whose multimillion-dollar violins need work do not package them in bubble wrap and drop them off at the UPS Store—they bring them in person.

ACT FIVE: THE ARTISTS ENDURE

STUDIO 917

HAMMERSLEY ARCHITECTS

WHEN ARCHITECT BRIAN HAMMERSLEY BECAME A TENANT OF THE FINE ARTS BUILDING, HE PITCHED HIS SERVICES TO THE OWNER AND SOON FOUND HIMSELF THE ON-CALL ARCHITECT, overseeing everything from bathroom and suite renovations, to a new stage at the Studebaker Theater, to a full renovation of the theater to ensure it was code-compliant, accessible, comfortable, and acoustically tuned. That work didn't come cheap.

"Erica Berger," he said, "is an absolute patron of the arts."

The bulk of his architectural practice is contemporary and forward-looking, focused on social equity, art as a concept of self-expression, creative space and community art, social housing, and green living. He chooses projects

> **" I DON'T SEE THIS BUILDING AS OLD AND DECREPIT. I SEE IT AS THIS REALLY BEAUTIFUL LIVING ORGANISM. LIFE HAPPENS HERE. "**

for his boutique firm based on social impact whenever possible and enjoys crunching data to see how buildings can positively affect their surroundings.

"Our work focuses on art and architecture and how they combine, also on residential and community space," he said.

The Fine Arts Building's lobby, façade, and elevators are protected as Chicago Landmarks, which both safeguards their history and creates challenges when updates become necessary. But those challenges are all part of the charm for Hammersley, who said the building reminds him of Wes Anderson's *The Grand Budapest Hotel*.

"This place feels domestic to me," he said. "It's not an office building. I don't walk into some swank-ass lobby and have to throw down a card. I walk in and the elevator guy knows my name and where I'm going. I think some of the things that happen here consequently feel a little more personal.

"I don't see this building as old and decrepit. I see it as this really beautiful living organism. Life happens here."

ACT FIVE: THE ARTISTS ENDURE

STUDIO 904

PERFORMERS MUSIC

LEE NEWCOMER OPENED PERFORMERS MUSIC ON VALENTINE'S DAY, 1981, AND RAN THE STORE UNTIL HIS DEATH IN AUGUST 2024. A tall man with long, silver hair, in later years walking with the help of a cane, he cut a distinctive figure in the halls of the Fine Arts Building.

Today, the store he founded is said by some to be the last independently owned sheet-music store in a large American city. They offer a wide selection of sheet music—mostly classical but also jazz, show tunes, vocal standards, and method books—to customers who include teachers, students, and professional performers. The shop also sells recorders and accessories such

" THIS IS STILL A VERY GOOD WAY TO GET MUSIC BECAUSE YOU CAN LOOK AT IT, YOU CAN TURN THE PAGES. "

ACT FIVE: THE ARTISTS ENDURE

as music stands, stand lights, reeds, mutes, and lubricants.

Although two-thirds of the sales are now made via the website, regular customers come from all over the world, some of them making large purchases when they do stop in.

"This is still a very good way to get music because you can look at it, you can turn the pages," Newcomer said before his passing. "Increasingly, people buy music the way they buy most things: online. But I'm encouraged by the fact that there are a lot of young people—grade school, junior high, high school, college people—who come here and like doing this."

ACT FIVE: THE ARTISTS ENDURE

STUDIO 729

RED BIRDS EVERYWHERE

JAHMAL HEMPHILL HAS A BARBER'S LICENSE AND A MARKETING DEGREE. After working in shops and salons large and small, he decided to go into business for himself. He visited the Fine Arts Building and fell in love with the idea of going downtown, riding the manually operated elevators, and hearing pianos playing in the hallways. He also liked the idea of being around others working to hone their crafts. He moved in during the summer of 2020, as soon as the city allowed barbers to start cutting again after the Covid-19 shutdown. From his shop, Red Birds Everywhere, he offers haircuts, headshots, graphic design, and marketing services.

"If you're an athlete, you should go to a gym," he said. "If you're an artist, you should go somewhere like this."

Is he an artist, too? "My art lives and dies within two weeks. Everybody else is essentially recording or documenting something that will be at reach or attainable forever. I'm shaping how a person looks, or maybe how they think or feel that day. But it's going to disappear."

ACT FIVE: THE ARTISTS ENDURE

STUDIO 833

CHICAGO YOUTH SYMPHONY ORCHESTRA

THE TENANT WITH THE LONGEST TENURE IN BUILDING HISTORY WAS VIOLINIST AND COMPOSER GEORGE PERLMAN, who taught violin in studio 636 from 1926 until 2000, when he died at age 103. That's seventy-four years.

The longest *active* tenant has outlived many of its founders: the Chicago Youth Symphony Orchestra.

Founded in 1946 by eight north-suburban high schoolers who bonded during summer camp at Michigan's Interlochen Center for the Arts, by early 1947 the group was rehearsing in the auditorium of the Wurlitzer Music Store at 111 South Wabash. Helped along by some parental connections and fundraising, what was then called the Youth Orchestra of Greater Chicago had its first concert on November 14, 1947, at Orchestra Hall. In black-and-white historical photos, the musicians look shockingly adult—yet all were required to resign their seats after graduating from high school.

In 1959, auditions and rehearsals moved to the Fine Arts Building, and the organization has been headquartered there ever since, in studio 833. The current name was adopted in 1988, when the mission expanded to include several community-based sites for younger musicians. The mission statement—"To inspire and cultivate personal excellence through music"—actually seems a little outdated, given the current scope of CYSO activities.

A full-time staff of eight, along with roughly twenty part-time conductors and coaches, works with hundreds of talented young musicians, aged six to eighteen, in first through twelfth grade. The fourteen ensembles range from the full orchestra to a jazz orchestra and a steel pan and percussion ensemble. And while Symphony Hall performances are still CYSO's signature event, each season includes many different kinds, from school and community concerts to chamber music.

According to staff, CYSO students seek challenges and thrive when they're surrounded by other kids who are equally passionate about music. But the programs aren't for advanced players only. While the top ensembles are reserved for those who are seasoned musicians despite their tender years, the steelpan ensembles require no musical background at all.

Some students interact with CYSO off-site at public schools but far more of them come to the Fine Arts Building. The building can be quiet during the week, but not so on weekends, when each day some three-hundred instrument-carrying kids pack the elevators and tromp up the stairs to the eighth-floor rehearsal room, the steelpan and percussion studio, and tenth-floor Curtiss Hall.

ACT FIVE: THE ARTISTS ENDURE

Parents who accompany them—half come from the suburbs, some from as far away as Indiana—crowd the parent lounge, kill time on hallway benches, or disappear to nearby restaurants and coffee shops. Some families travel hours each way to participate in the prestigious program. The CYSO's distinguished alumni include music professors as well as star musicians at many large civic orchestras. Demarre McGill, principal flautist for the Seattle Symphony, is an alum, as is his brother Anthony McGill, principal clarinetist for the New York Philharmonic.

Alum Mary Elizabeth Bowden recorded a trumpet concerto for Cedille Records backed by the CYSO. Pop-music phenoms Laurie Anderson and Andrew Bird, a generation apart, played in CYSO, too, as did BET co-founder Sheila Johnson, the world's first Black woman billionaire.

CYSO students have performed with Chance the Rapper on *Late Night with Stephen Colbert;* accompanied the McGills on their album *Winged Creatures*; supported Ben Folds at the Chicago Theatre; played with My Morning Jacket at Lollapalooza; backed Blue Man Group at the Pritzker Pavilion; and even been featured in the Chicago Bulls' video holiday card.

They're so famous you might wonder who is supporting whom.

MAKE DOPE STUFF EVERY DAY

ACT FIVE: THE ARTISTS ENDURE

STUDIO 619

ABIOYE FILMWORKS

GROWING UP IN DETROIT, ADEWOLE ABIOYE KNEW HIS YORUBA PARENTS FROM SOUTH WEST NIGERIA EXPECTED HIM TO BE A DOCTOR, LAWYER, OR ENGINEER. He studied political science at Michigan's Oakland University and made plans for law school, but his heart wasn't in it. He loved movies.

He moved to Chicago, and in 2010, started film school at Columbia College. While making a short film about a painter, *Pieces of Anna*, he filmed a scene in the Fine Arts Building studio (632) of Tiffany Gholar, his roommate's sister. Her creative space made a huge impression.

"I promised myself I was going to get a studio, not knowing the circumstances behind how that would happen," he said.

After film school, with work starting to come in, he found it difficult to focus with his young family crowded into their Rogers Park apartment. In August

| 157 |

ACT FIVE: THE ARTISTS ENDURE

> " A PAINTER, IF YOU HAVE AN IDEA, YOU CAN GO STRAIGHT TO A CANVAS AND PAINT. A FURNITURE MAKER, IF YOU WANT TO BUILD SOMETHING, YOU CAN DO IT... BEING A FILMMAKER, YOU KIND OF NEED AN ARMY TO REALIZE THAT VISION. "

2020, he leased studio 619, a move he calls "a blessing," adding, "I feel lucky to come to work here every day."

His projects include documentaries about St. Louis painter Cbabi Bayoc, Chicago woodworker Lawrence Calvin D'Antignac, and furniture maker and conceptual artist Norman Teague.

"I think there's a part of me that wishes I worked with my hands in some capacity," says Abioye. "A painter, if you have an idea, you can go straight to a canvas and paint. A furniture maker, if you want to build something, you can do it... Being a filmmaker, you kind of need an army to realize that vision."

ACT FIVE: THE ARTISTS ENDURE

STUDIO 310

CHICAGO INTERNATIONAL PUPPET THEATER FESTIVAL

BLAIR THOMAS, ARTISTIC DIRECTOR AND FOUNDER OF THE CHICAGO INTERNATIONAL PUPPET THEATER FESTIVAL, HAD LONG WANTED A STUDIO IN THE FINE ARTS BUILDING. After all, it had been home to the Chicago Little Theater and pioneering puppeteer Ellen Van Volkenburg, the woman who coined the word for those who performed the art. (See "Interlude: The Theaters.")

Thomas began putting on marionette shows at churches and birthday parties with his first company, Palace Puppeteers, at ten years old—but stopped in high school because it felt like kid stuff. After focusing on literature, music, and theater in college, he arrived in Chicago in 1985 with plans to become a director. But his work in traditional theater left him uninspired.

A few years later, he attended a workshop by Els Comediants, a troupe from Barcelona, in which the anarchic Spaniards challenged attendees to build

> " I FELT LIKE I HAD SORT OF BECOME CRAZY. LIKE THERE WAS SOME GARDEN GATE THAT WAS OVERGROWN, I PUSHED IT OPEN AND STEPPED INSIDE, AND THERE WERE THE MOST WILD THINGS GROWING IN THIS GARDEN. AND IT WAS SO FANTASTIC, AND I FELT LIKE I NEVER HAD TO LEAVE THIS PLACE. "

puppets from alley scraps, then rehearse and perform a sidewalk show—all within three hours. It seemed inconceivable and yet they pulled it off. Watching their wordless performance of *Alè* that night, Thomas found his mind blown by the possibilities.

"I felt like I had sort of become crazy," said Thomas. "Like there was some garden gate that was overgrown, I pushed it open and stepped inside, and there were the most wild things growing in this garden. And it was so fantastic, and I felt like I never had to leave this place."

He went on to found, with Lauri Macklin, Redmoon Theater Company, a legendary and influential outfit specializing in site-specific, large-scale spectacle. After doing that for a decade, he founded a not-for-profit, Blair Thomas and Company, at which he labored for fourteen years. Financially, it was "a pathetic, desperate situation."

But he was still thinking big. "And I just said, well, if there were a Chicago International Puppet Theater Festival, I would be a good candidate to be the director. I would apply for the job. And then I just thought, why don't I make it instead?"

The festival's first iteration, in 2015, was a festival in name only, a grouping of independent productions. But it has grown and grown. The now annual event has a budget nearing $2 million and employs five full-time employees, six part-timers, and a rotating cast of contractors. It is North America's premier puppet festival, often playing to sold-out crowds.

Thomas, with executive director Sandy Smith Gerding, has made the Fine Arts Building a true hub for the art. Through the Chicago Puppet Studio (with Tom Lee as principal designer and artist), they design and fabricate puppets for puppet shows, yes, but also plays, movies, and even corporate events. They've made puppets for the Metropolitan Opera in New York City and a corporate retreat in Mexico, too.

ACT FIVE: THE ARTISTS ENDURE

Their Chicago Puppet Lab is a highly competitive new-works development program in which eight projects per year are chosen by committee and given creative, financial, and marketing support. They have also begun offering residencies.

"Artists need time, space, and money to make work," said Thomas.

They also need an inspiring place to do it.

The fledgling festival first rented a single studio (501) at the Fine Arts Building in 2016. Bursting at the seams, in 2021, they moved their administrative offices into the old-world elegant studio 310, overlooking Michigan Avenue, and their maker space into 433, a large suite adjacent the Venetian Court. Thomas had no idea the latter had once been occupied by his hero, Ellen Van Volkenburg.

"I had walked around [the building] and was like, 'Where could it possibly have been? It was a hundred-seat theater,'" Thomas recalled. "We were renting it because it was available, not because it was the Little Theater. And I can't believe it turned out to be the Little Theater."

ACT FIVE: THE ARTISTS ENDURE

STUDIO 210

EXILE IN BOOKVILLE

JAVIER AND KRISTIN RAMIREZ, THE OWNERS OF EXILE IN BOOKVILLE, BONDED OVER BOOKS—AND THEN FELL IN LOVE. In early 2020, veteran bookseller Javier was working to launch a West Loop bookstore when avid reader Kristin (née Gilbert), who lived nearby, began ordering books even before the grand opening. The author who brought them together was John Williams, whose *Butcher's Crossing* was one of Javier's favorites; Kristin was incredulous that he hadn't read Williams' *Stoner*, her favorite book.

Soon they were romantic partners, eager to become business partners with a bookstore of their own. They were firming up plans for a location in Logan Square when they were contacted by the owners of The Dial, who wanted to sell their used bookstore on the second floor of the Fine Arts Building.

| 165

" WE HAVE A FIRM BELIEF THAT BOOKS AND MUSIC ARE INTERTWINED, SO WHAT BETTER PLACE FOR OUR STORE THAN A BUILDING THAT HOUSES ART IN ALL ITS FORMS? "

ACT FIVE: THE ARTISTS ENDURE

"When we were first approached about it, I thought, no way do I want a second-floor store," said Javier.

"Both of us said, 'Hell no,'" Kristin recalled.

But after giving it some more thought, they saw the space differently.

"The different kinds of art were a big draw to us," said Kristin. "We have a firm belief that books and music are intertwined, so what better place for our store than a building that houses art in all its forms?"

They opened Exile in Bookville (its name an homage to Liz Phair's album *Exile in Guyville*) in 2021 and spent a year selling off the used stock to fill the shelves with carefully selected new books. Both of them worked seven days a week while Kristin continued to teach criminology, sociology, and political science full time at Elmhurst University. She left in 2022 to focus on the store. They married in 2024, only two blocks away.

Only a few years into their business venture, sales were booming, and the calendar was crowded with prestigious author events. Both had come to see their second-floor location as a feature, not a bug.

| 167 |

"It takes a dedicated weirdo and book nerd to come up here," laughed Kristin.

"It separates the wheat from the chaff," agreed Javier.

The customers have continued to come. Some are social media users chasing bookstore vibes—twenty-foot-high bookshelves, enormous picture windows, and Michigan Avenue views will do that. But most are serious readers. They are locals and tourists, students from nearby schools and their parents. Visitors from other countries are blown away by the books they can't find at home.

The Ramirezes stock some bestsellers in their general-interest store but take pride in hand-selling thoughtfully selected backlist books, small-press titles, and translated works. Their love of music is evident in a prominently displayed series of books about famous albums and in the music they play over the store's sound system. They sell vinyl, and shoppers can browse the listening racks and choose something to play on the store's turntable.

In previous decades, Javier worked in so many bookstores that, according to Kristin, "It's easier to count the places he hasn't worked." But he seems to have finally found a home in the Fine Arts Building.

Javier agreed. "This is it."

925

908

FINE ARTS BUILDING 410

ACKNOWLEDGMENTS

I want to thank Brian Hieggelke of *Newcity* for giving me the assignment to write about the Fine Arts Building in the first place—sure, a couple of Manhattans helped grease the skids, but it was the project and challenge I didn't know I needed at the time. Many thanks also to Jan Hieggelke for shepherding a very, very long magazine article to publication and keeping track of details I didn't know existed. Ray Pride caught several key mistakes. Any errors in this book, which is a revised and expanded version of my article, are mine alone.

While other Chicago publishers also graciously offered to work with me, the enthusiasm and ideas of Sam Landers and Michelle Fitzgerald at Trope best matched my vision for what this book could become—and I'm thrilled to see what we have created together. I'm grateful to Tom Maday for his beautiful photos and forever indebted to Kendra Huspaska for her gorgeous cover and above-and-beyond work on the interior design.

Gillian Flynn: you're the best!

The owner, management, and artistic team of the Fine Arts Building helped me every step of the way by answering questions and allowing me access to the building, staff, and archives. I thank Erica Berger, Jacob Harvey, Joaquin Williams, and Idalis Huerta for their time, expertise, and insights. Special thanks to Alexander Attea, staff historian and keeper of the archive, for his ongoing and enthusiastic assistance.

Brian Hammersley, who has played a unique role in the renaissance of the FAB, deserves a special shout-out for his help on multiple fronts.

Thank you to Mary Graham for sharing memories and showing me photos in the garden of her lovely home.

Big hugs to Javier and Kristin Ramirez at Exile in Bookville for friendship, professional support, and bourbon at the end of a long day.

Sincere gratitude to my neighbors in the Fine Arts Building, where I have found the colleagues and community I missed since leaving my job at the American Library Association's Booklist Publications. A great many have helped with this book in large ways and small—and mercifully, nobody has scolded me (at least, not yet) for leaving someone out or getting something wrong. Extra-special thanks to Bill Lee, Eli Biagi-Lee, John K. Becker, Blair Thomas, Cecilia Beaven, Adewole Abioye, and Jahmal Hemphill.

Engineer extraordinaire Marcin Krol provided fascinating insights into the building's inner workings during an unforgettable basement-to-rooftop tour. And the elevator men—Waclaw Kalata, Robert Kurdej, Brian Feeley, and Nevada Bradley—have always been an important part of my day as we share the ups and downs.

Rest in peace, Tom Graham and Lee Newcomer. I wish I could have shown you my book about the building you loved so much.

Endless love to my wife, Marya Graff, to our daughter, June, and our son, Cosmo.

840

KEIR GRAFF
Author

ABOUT the AUTHOR

STUDIO 840

KEIR GRAFF IS THE AUTHOR OR COAUTHOR OF FOURTEEN NOVELS AND THE EDITOR OF TWO ANTHOLOGIES. With Linda Joffe Hull under the pen name Linda Keir, he writes mysteries and thrillers about marriages in trouble; with James Patterson, he writes the MK's Detective Club series for middle-grade readers. The former executive editor of *Booklist*, he is also the cofounder of Publishing Cocktails Chicago and the cohost of the Filmographers Podcast. An in-demand speaker and teacher, he provides writing advice and book recommendations in his free monthly newsletter, Graff Paper. He does his best writing in his studio on the eighth floor of the Fine Arts Building.

IMAGE CREDITS

Principal photography by Tom Maday, except where noted below.

Tom Maday's editorial and commercial assignments have taken him to every corner of the globe including Africa, the Middle East, the Indian subcontinent, Latin America, Europe and throughout Asia. His clientele includes international brands and companies such as ESPN, Abbott, Sappi Paper, Motorola and TD Ameritrade. Tom has shot portraits of public figures in music, film and politics for the *New York Times*, *Chicago Magazine*, *Interview*, and *Entertainment Weekly*, to name just a few. He has also worked on location in Kenya for GE and in Botswana for Merck, documenting the companies' leadership initiatives and social programs.

Cornell University Library,
A. D. White Architectural Photographs
Page 20

Library of Congress
Pages 21, 73

Chicago Daily News Collection, Chicago History Museum
Pages 22, 24, 27, 32, 35

The Book of the Fine Arts Building: A Facsimile Edition of the Original Monograph; David Swan
Pages 23, 25, 37, 68, 76

Chicago History Museum
Pages 26, 36, 53

Courtesy International Studio
Page 37

Chicago Sun-Times/Chicago Daily News collection, Chicago History Museum
Page 46

Chicago History Museum, Hedrich-Blessing Collection
Page 56

Chicago Youth Symphony Orchestra
Pages 57, 58

Chicago Public Library
Pages 60, 61, 66, 67, 78

Chicago History Museum; Frederick O. Bemm
Page 62

Mikel Pickett
Pages 66, 67, 78, 79, 101, 140

John P. Keating Jr.
Page 69

Courtesy NBC
Page 70

Chicago History Museum; Louis F. Zimmermann
Page 74

Courtesy Mary Graham
Pages 85, 86

Ronnie Frey; @doorwaysofchicago
Page 89

Courtesy Jesse Ashton
Page 100

Chicago History Museum; John McCarthy
Page 107

Courtesy Cecilia Beaven
Page 133

Chicago Youth Symphony Orchestra; Haoshu Deng
Pages 150, 151, 152, 153

All historical photos have been reprinted with permission, except for those that fall under public domain and are not protected by intellectual property laws.

Special thanks to Alexander Attea, Manager of Marketing & Communications for the Fine Arts Building, for his ongoing assistance and support with archival images and the building's rich history.

OPPOSITE PAGE Lead Guard Imani Bowman at the front desk

©2025 Trope Industries LLC.

This book and any portion thereof
may not be reproduced or used in any
manner whatsoever without the express
written permission of the publisher.
All rights reserved.

©2025 Text by Keir Graff
©2025 Photographs by Tom Maday
except as otherwise credited

Cover and interior illustrations
by Kendra Huspaska

LCCN: 2025930704
ISBN: 978-1-951963-33-0

Printed and bound in China
First printing, 2025

Trope Publishing Co.

+ INFORMATION:
For additional information
on our books and prints,
visit trope.com

TROPE

TROPE PUBLISHING Co.

LONGITUDINAL SECTION